CHARACTER DESIGN QUARTERLY

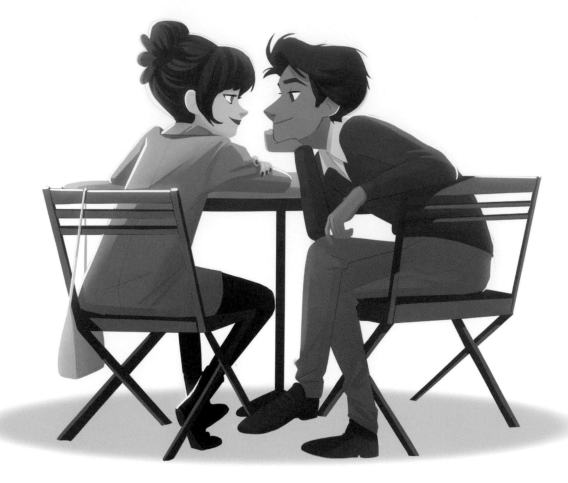

Image © Noor Sofi

CONTENTS

WELCOME TO *CHARACTER DESIGN QUARTERLY* 15

My favorite thing about this issue is that it's packed with storytellling, which is at the heart of character design. There's fantasy, magic, and a touch of romance for good measure. All alongside some invaluable tips and advice from incredible artists.

We start with some epic career advice from the inimitable Bobby Chiu – our star cover artist and co-founder of Imaginism Studios. In a personal interview, we talk to Bobby and co-founder Kei Acedera about their careers so far, the importance (or not) of a formal education, and why the industry is changing thanks to a little virus that shall remain nameless.

I hope in the pages of this issue you can escape, as I did, into a magical world of intriguing human characters, mythical beasts, enchanting storytelling, and artists discussing the simple joy of being a creator. And if you can take away a few tips to improve your character design along the way, so be it!

SAMANTHA RIGBY
EDITOR

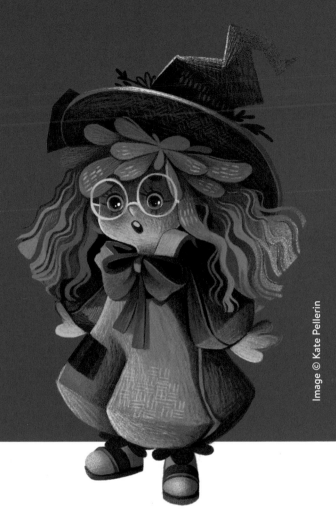

Image © Kate Pellerin

68 78 88

MEET THE ARTIST: OONA HOLTANE

Oona, character designer at Netflix Animation Studios, talks to us about her career and shares some personal work

THE GALLERY

Sit back and enjoy some inspirational work from character artists Meggie Johnson, Maya Lior, and Sarah Beth Morgan

CHARACTERS WITH A STORY TO TELL

An enchanting tutorial from Chaymaa Sobhy, who demonstrates how she designs story-based characters

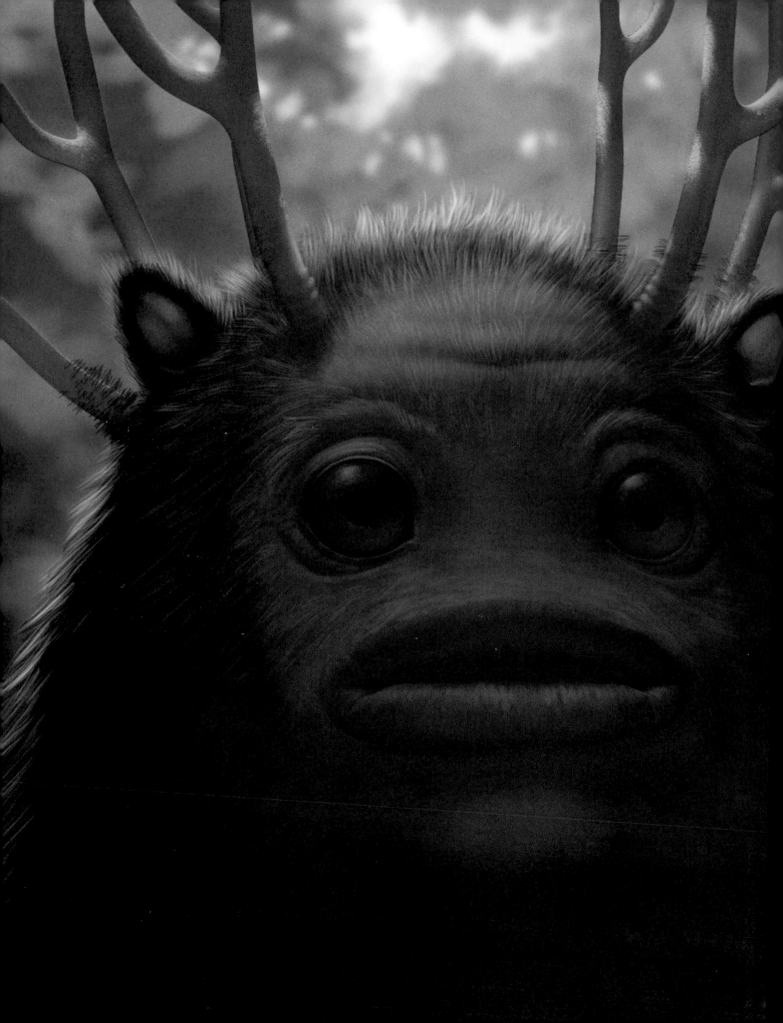

IMAGINISM

STUDIOS

We speak to the co-owners of Imaginism Studios, Kei Acedera and Bobby Chiu – the latter being the creator of this issue's incredible cover art. The pair have been running their Toronto-based studio since 2005, specializing in pre-production character and concept design for film, TV, gaming, and publishing, and they also run online learning platform Schoolism and the LightBox Expo. They talk about the conception of the studio, their passion for learning, and the importance of finding balance in work and life.

Hi guys and thank you so much for speaking to us. Could you tell us about the studio – how it began and how it evolved to where it is today?

Kei: Thank you for having us! We founded Imaginism Studios fifteen years ago. I was still in college, and Bobby had recently finished.

Bobby: I had been working for almost a year at that point. I had graduated and was doing a job I didn't want to do – working for a TV studio as a data manager, which doesn't involve a lot of drawing! That's why I wanted to start the studio. I would do a lot of drawing as I worked, and became known as the computer guy who liked to draw. Eventually they took away my pencils because I was drawing too much on the job, so I started drawing with a pen instead! Then I started to do freelance work at night. I was doing around eight hours each night on top of the eight-hour day shifts at my job. That carried on for a few months before I decided to quit the day job. I launched the studio with my brother Ben – and Kei quickly joined as soon as she could, because I needed help with projects.

Kei: As my design work picked up, it made sense for me to quit college. I had been paying my way through by finding jobs that would pay the fees. Then, Disney asked me to design a cartoon show called *Jake and the Neverland Pirates*, which I rarely talk about – nobody really knows that I designed it, because it was so long ago. It took a while to make so I don't think anyone ended up being credited for the designs – I'm fine with that though, because it's those humble beginnings that get you where you are. I was grateful for the opportunity and it made sense to transition from formal education into that work. Then I started to work with Bobby for the studio, too. We kept getting projects thrown our way, so it just made sense to pursue those opportunities. For me as an artist, practical experience and practice was the root of my career.

Bobby: One of the first projects we did together was to make a TV show, which we

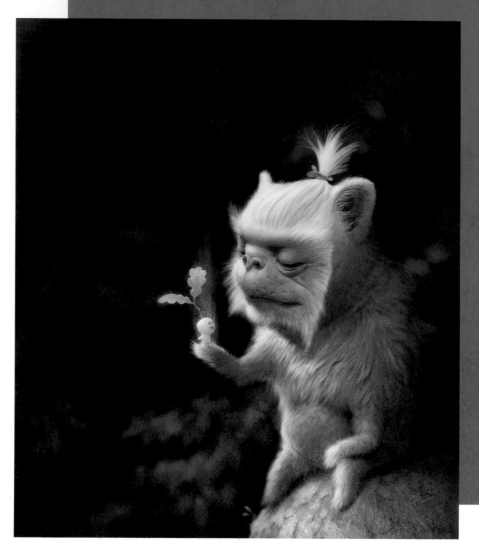

sold to the TV studio I had worked for. The computer guy sold them a TV show! So that was a big catalyst to get things started. It didn't get made in the end, but we sold the option and got really excited. Then we went to Comic Con and I feel like that's where we really got discovered.

With art education, it seems a lot can be learned "on the job" and from the practical experience of actually doing projects. Would you agree?

Kei: Yes, it's not like practicing medicine – we don't operate on bodies – it's more of a soulful thing that depends on life experiences and technical practice.

Bobby: It's about building contacts and putting yourself out in the world, too. That first Comic Con trip was very special – it's where Tim Burton and his people discovered us. We had business cards with a full illustration on the front and our details on the back – we had a whole bunch of different cards with different images, so it was like a mini portfolio. People took them, and one of those people was someone who worked for Tim Burton. We got contacted to work on Alice in Wonderland, the first of the slew of classic literature that was getting remade at the time.

This page: *Spring is Coming* by Bobby Chiu
Opposite page: A 90-minute art challenge by Bobby Chiu

"Practical
experience and
practice was the
root of my career"

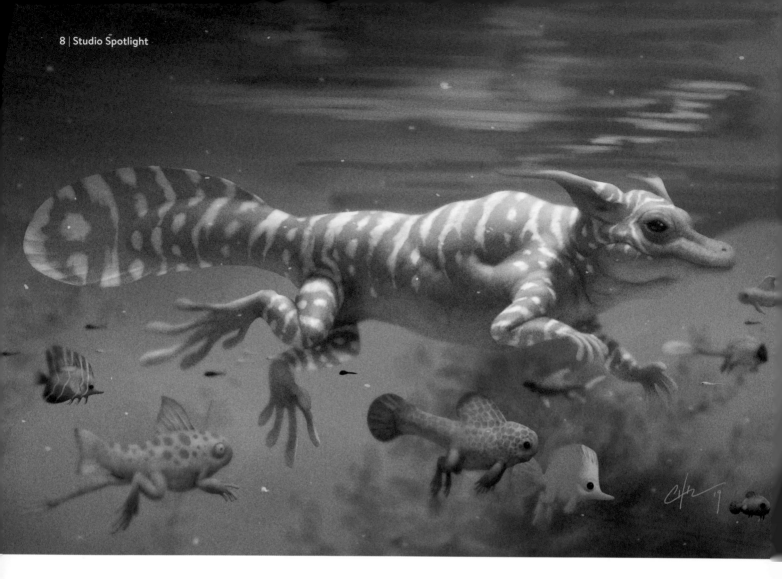

It must have been so exciting to work on that movie. What was your involvement? Were you given a strict brief or was it quite open to interpretation?

Bobby: When people mention it, I never know whether to apologize or to say "you're welcome." It's such a polarizing movie! It was pretty much just three designers working on all the characters, and we were two of them. I think the list of characters was around 90 characters long, which is quite a lot for a film. We got to touch each one of them at least a little bit. At first we were almost given no direction – they said okay, read the script, choose a character you like, and do what you think works. Then, if Tim likes it he'll take it and give some more direction. I had never had an experience like that before.

Kei: That was one of the rarer smooth projects because Tim just knew what he wanted – his vision is so strong.

Bobby: We actually never got to communicate with him in person or words – just through drawings sent via the production designer, Ken Rolston, who is one of our heroes. He was a supervisor on the original

Star Wars – he's awesome. The *Alice* movie took nearly two years to come out. We went to Paris to watch the premiere, where we were doing a gallery show, and then we did a bunch of interviews. Disney arranged for us to watch the movie in the theatre. We walked in and saw two reserved seats, and we thought they must be for someone important, so we sat near them. Then all these reporters came in, and the founder of the Cannes Film Festival, but nobody sat in those seats... it turns out, they had been reserved for us! And then the movie came out, and it was number one in the box office and one of the top four highest-grossing movies ever, and then the calls started coming in.

How did you deal with suddenly receiving lots of offers? Were you were inundated with work?

Bobby: When that time comes, if it comes, and you get too many offers, the ability to say "no" is just as important as the ability to say "yes." You need to be giving everything your best and putting out only top-quality work, and if you take too many offers, the quality of your work will diminish. You might get the fear that those offers or producers won't come back to you, but they will.

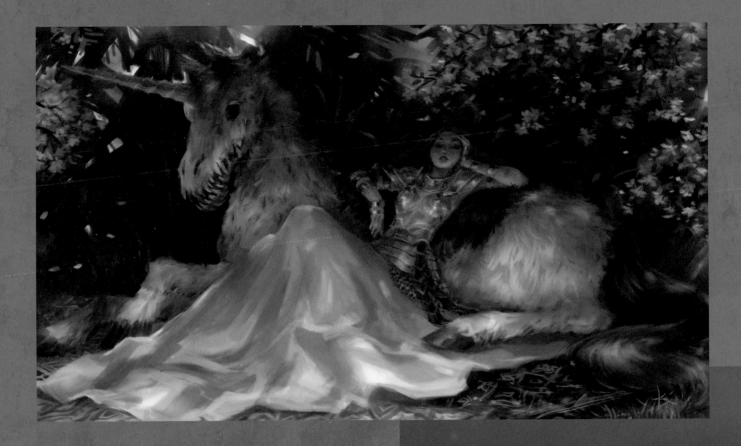

Kei: You'll burn yourself out – it's a common thing for artists, especially in our position. With freelance work, you have to drive it forward yourself, but also balance your time and know when it's too much. The level of offers is never going to be a constant thing, and you have to keep the ball rolling. It comes with its benefits – you have the freedom to control your own time and choose who you work with.

"You need to be giving everything your best and putting out only top-quality work"

Opposite page: *Floater* by Bobby Chiu
This page (above): *Chilling with Unicorn* by Kei Acedera
This page (right): *Scooper Unicorn* by Bobby Chiu

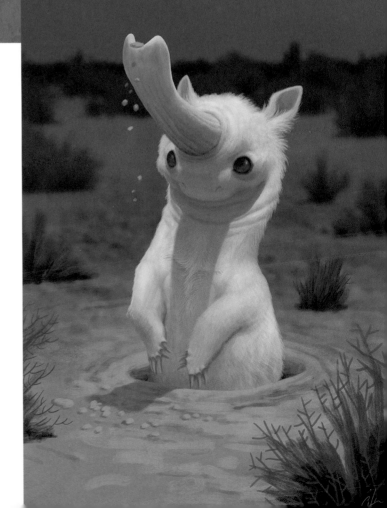

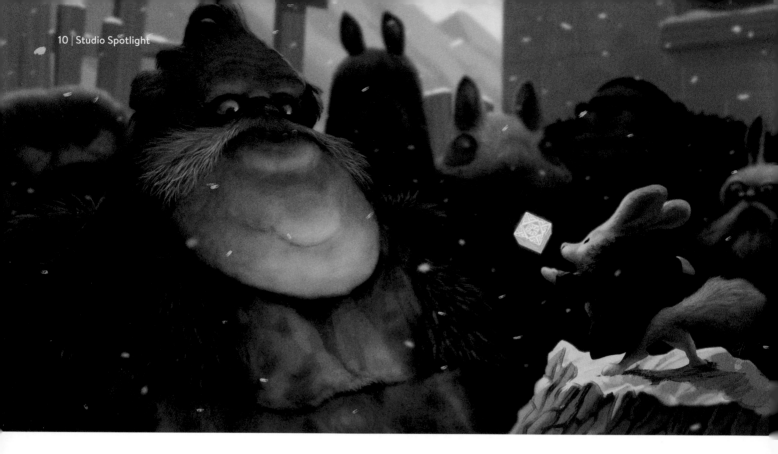

So how do you think the studio has progressed since then, or do you work more or less in the same way?

Bobby: In the very beginning, we worked in my parents' basement for a month! Then we graduated to two condominiums over two floors. We lived there as well. Then we switched to a big house and we all lived there – it became a weird kind of commune, but it served a purpose and we saved a lot of money.

Kei: It was very much a student-into-early-professional-life vibe. You're so *gung ho* to be working hardcore all the time, and you have that energy in you. I think every artist should experience that, or something similar. You're just engulfed in art. You think about other stuff too, sometimes, but all your conversations are about how to improve your art, or about philosophical stuff that surrounds art.

Bobby: Those were awesome years. Anytime you woke up there would be someone who was already up and painting – that's such a great experience. But we do have an actual studio now in Toronto, and we love it! There's a big

warehouse in the back to make all sorts of big things if we want to. There are around 12 or 13 of us there currently, and then we have a graphic designer / artist in Singapore. Plus, we have over 30 teachers for Schoolism.

Tell us more about Schoolism. How did that come about?

Bobby: Well, let's travel back to that Comic Con trip. We're there and we're total newbies, just us having dinner together every night. We knew nobody. One of our favorite artists, who is now one of our best friends, Stephen Silver, invited us out to dinner. At dinner, I brought up this idea to create a modern version of something that Norman Rockwell did. He created this artists' course, with him and his friends, where you buy giant textbooks to do assignments, mail your drawings out, and then you would receive them back a few weeks' later with some tracing paper over the top, and a professional artist had looked at it and gone over it with improvements and notes. I said to Stephen, we can use the internet to make a 2000s version of this. I suggested he could do the lessons and put them up on a site,

then I'll watch them and make sure they work, and as a bonus I would get to learn for free! He said, "yeah, that sounds great" and so we did it. I often have these ideas and start rolling with them a little too quickly. I've learned to take things a little slower now, though!

The whole purpose of Schoolism was for us to learn from these artists that we admired. Getting them all in one place so they're not split across the internet. There is so much you can see in somebody's sketches, and they can explain what's going on inside their heads as they're doing it, which is where the "secret sauce" is.

It's clear that learning is a real passion of yours. Would you say that learning as much as possible is the best key to getting noticed in the world of art and design?

Bobby: Yes, and one of the things that we really believe in is that it doesn't matter where you live. If you have an internet connection, you can learn so much and connect with so many people, then the world will have no

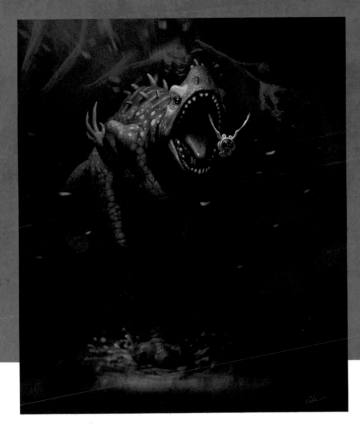

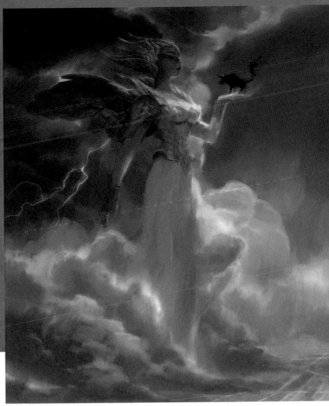

choice but to notice you. As for learning as much as possible, it's great to be versatile but also valuable to work out what you enjoy and are best at. If you look at any facet of art, you could just study that one little slice for the rest of your life. You could just study color for the rest of your life and still not be done.

Kei: Back at school, there were some teachers who would say it's good to be a "jack of all trades." And yes, it's great to learn to do all sorts of things, but to get noticed it's always good to specialize in something. Then once you get your foot in the door, you can always branch out and learn new things. That's something that students don't always realize, because there's so much being put in front of you to learn all in one go. That said, there are crazy-good artists that can do multiple things really well – you don't see it very often, but they do exist.

When it comes to getting noticed, it's also very helpful to go to art events, to build those connections. People still want to see and get to know you in person. There is still a barrier in digital communication, and you can't truly know someone – showing clients you are personable and enthusiastic is so important.

It's difficult for artists to work out the best area to focus on. Did you always have a clear vision of what you wanted to do as a studio?

Kei: I think we knew what we *didn't* want to do and kind of started from there.

Bobby: Yes, and made lots of mistakes. The whole idea of getting yourself out there, getting to a point where people notice you, is really about how special your stuff is. So, if you try to do a bit of everything, how special will it be? How long will it take to get above the average and start to get noticed? It might take six or seven years to try to learn everything, or I could concentrate on one thing and really isolate my learning, which might only take one year. And after that, you can move on to other things. So, we started on character design, then moved on to live action, then started to learn how to paint realistically. Once we'd done that, we got more into full scenes. Our comfort zone gradually grew, and we really dived into every new project – take our book *Water Worlds* for example, we totally focused on that, started learning about all these underwater creatures, and built up our knowledge.

Opposite page: *Lightbox* by Bobby Chiu
This page (left): *Romp* by Bobby Chiu
This page (right): *Calm Before the Storm* by Kei Acedera

What aspect of character design is most interesting to you?

Bobby: What I find interesting is how it can be entirely imaginative. I much prefer the whimsical and entirely fantastical, something for which you could barely find any reference to begin. Like Yoda, how would you describe Yoda from scratch? As the name of our studio suggests, we love to create stuff totally from our imagination. At the beginning we made fun of the name because we started in my parents' basement, so it was like an "imaginary studio." But of course, it was real! The idea for the name really came from the fact we make a living from our imagination.

So what would you say is an average day in the office for you guys? And when you get a project, how do you break down the work?

Bobby: Well everybody comes in at different times, between around 8am and 10:30am, as we're pretty relaxed. We have our own separate rooms, because we have a lot of meetings and recordings to do. Nowadays, we try to finish by 6:30pm. However, that depends on the project – sometimes you want to keep painting and drawing, so it doesn't always work. We have had many dinners at the studio, but only if we want to, which is a really nice position to be in. We actually only have one other artist working at the studio full time, and all the others are administrative or part of Schoolism – the stuff that helps to keep the studio running.

Our studio very much started with the motto "let's make this for the artist." Some studios are more focused on talking about the studio as a whole rather than the individual artists. We do the reverse. We consider who we specifically want to work on each project. We have Kei, Masai, and me – and sometimes Shiuan in Singapore. Sometimes we work on individual projects, but sometimes we need the help of our fellow artists. Ensuring everyone is happy is very high on our list at the studio. We feel like a team, a tribe almost. A well-oiled machine where many parts work separately but also together.

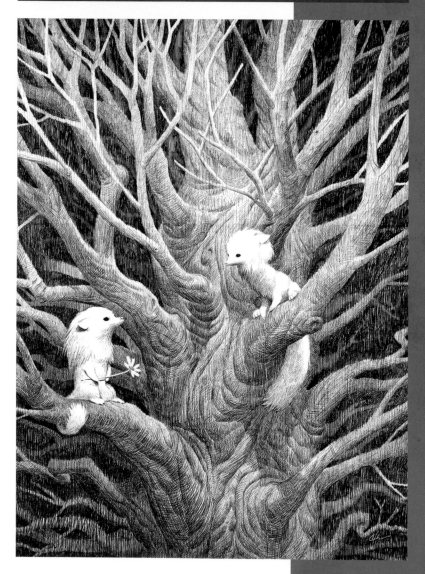

This page (top): *Mushroom Kid & Piranha Puppy* by Bobby Chiu
This page (bottom): *Love Tree* by Bobby Chiu

TEAM MEMBER PROFILE

Name:
Masae Seki

Job title:
Illustrator & Character Designer

Education:
Schoolism

Best bits of the job
Bringing designs to life! Also, seeing the works of other artists at the studio is so inspiring – it keeps me on my toes and helps me get better. I work as a freelance illustrator for children's books and a character designer for movies and TV shows. There are times when I collaborate with Bobby on live action movies where he creates the initial creature concepts and I help paint the design. However, we all work on different projects individually most of the time. It is a very relaxed and friendly environment where it's easy to talk to everyone in the studio.

Challenges of the job
I'd have to say the fear of failure, but that's probably true of most jobs! The thing is, whatever the outcome, I always learn something new about myself and my art with every project.

What advice would you give to budding character designers?
Everything you experience will seep into your art, so go out and see the world! Learn and observe people, things, animals, and places... never stop searching for knowledge.

TEAM MEMBER PROFILE

Name:
Shiuan Chan

Job title:
Graphic Designer & Artist

Education:
Diploma in Visual Communications
(and Schoolism)

Best bits of the job
That's easy! Being able to travel and meet, learn from and befriend my artistic heroes!

Challenges of the job
Being all the way across the world can be a challenge. I work remotely in Singapore and, time differences aside, I sometimes miss working with fellow painters and being able to easily ask for artistic opinions or advice. There's just something about working in a community that spurs you on, and inspires and motivates you.

What advice would you give to budding character designers?
I'm going to try to avoid the age-old advice like practice, learn anatomy, and so on, and say something that I am also learning to remember: Learn about your personal taste! It goes a long way to feed your style (which I believe comes from a combination of skill and taste). Try to understand why you react to some designs and not others, and extract your personal aesthetic sense. Sometimes what we enjoy visually might not be what we end up enjoy working on – we can surprise ourselves. Embrace it!

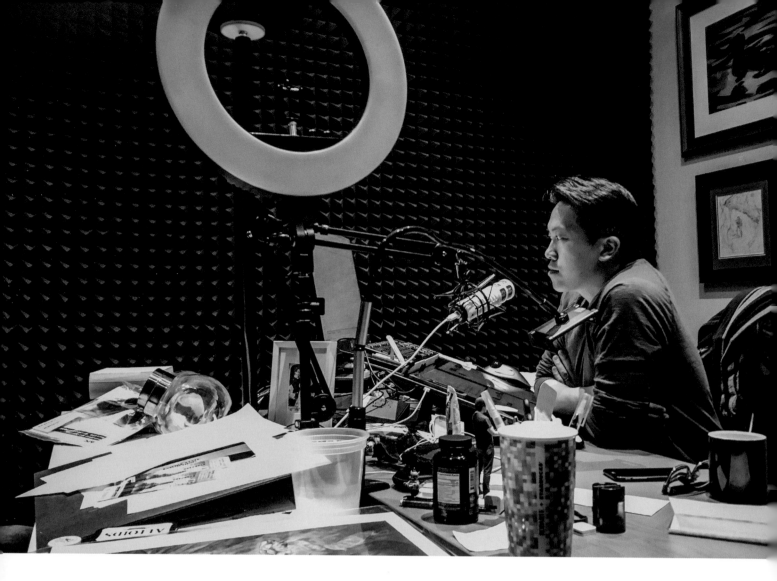

You have the studio itself, Schoolism, and Lightbox Expo too. Are there ever any times where things clash? How do you maintain your work/life balance?

Bobby: My schedule is pretty insane. Kei usually works on just films, and I will call on her if I really need her for something for Schoolism, but I try to stay out of her hair. We concentrate on the things we like to do, for example, I like doing YouTube videos and streams. But you can't always just let it happen organically, because of course we have deadlines.

Kei: I think, over the years, we've learned to pace ourselves and when to take breaks. It's never going to be perfect but trying to balance things makes a huge difference. And learning from your past mistakes. Also, as the owners

you tend to do more work, and once you accept that then you're good! With our online school, we do many workshops around the world, so we have the opportunity to travel. This not only gives us the chance to reach people and help them but also gives us a break from everyday life and allows us to venture out artistically.

Bobby: A big lesson we've learned and try to teach everyone is that, as well as characters and environments, your life is designable too! It's essential to find a happy balance between work and personal life. It's a puzzle and it's not easy – it takes conscious thought to figure out how to fit things together, but it's so important.

If you're looking to employ artists or work with them, what kind of qualities do you look for?

Bobby: Good communication skills, being able to articulate your thoughts, and being able to interpret other people's words. These are all things we never thought about as students. Something that many students don't realize about being a character designer is that you are the interpreter of the director's vision. They say things like, "Oh this character is too sweet, can you make it bitter?" – and you have to work out what that means.

Usually we discuss these things after we have a meeting with the art director. We find ourselves saying, "he was talking about a horse, but do you think he was really just talking about a horse or does it relate to the character?" or "they wanted the intensity of Al Pacino's eyes but didn't want the character to have Al Pacino's eyes." So, you need to work with people who are able to interpret all these

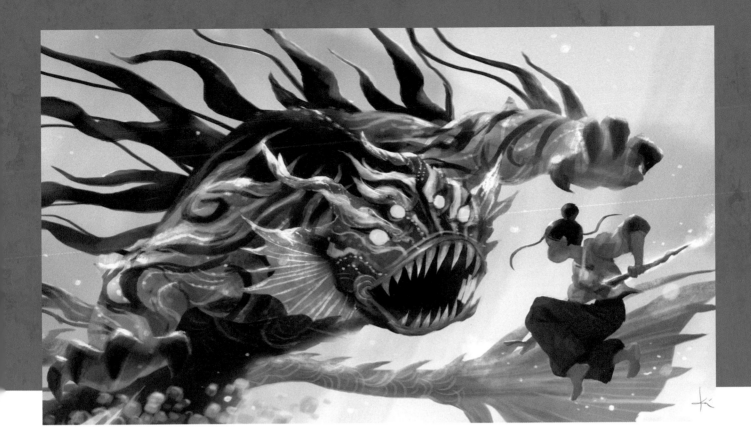

little clues and figure out how to give that expression, or feeling, to a character.

Technical skills are important of course, and a good understanding of design, lighting structure, textures, and surfaces. If they can evoke emotions with their paintings, through their art, that's huge – that's top level and what every artist wants to do. It's a challenge, but in the end we're trying to create emotions. And if they can play ping pong, that's a bonus!

Do you have any big plans for the studio, and how are you adapting to life during a global pandemic?

Bobby: Always – we always have big plans. It's just finding the time to do it all! We're thinking maybe we need a smaller space now, as perhaps people would rather work from home. So, things are changing a bit in terms of plans for the future. You know what though, something that your readers may like to think about, our plan was never to make a

giant studio with 1000 people – instead it's been all about making sure we're really secure. If things need to grow, then we grow it, but I feel there's too many people with the idea that it's all about how fast you can build your company and how big – but that doesn't always work out. It's much harder and you need some serious resources. The bigger you get, the more expenses you have. You can't measure success on the number of employees that a company has. You can do so much with a small team – and you can still celebrate everyone's birthday!

In terms of the work itself, we had Lightbox Expo online in September, and it was gigantic! We cancelled the in-person event because of the pandemic, but that meant we had even more people involved because it was online.

Kei: It felt really good for the community, especially during a time when it's harder to travel and connect.

"As well as designing characters and environments, design your life!"

Opposite page: Bobby in his studio

This page: *Girl vs water demon* by Kei Acedera

Art is a big part of that, isn't it, allowing us to escape a bit and focus on the brighter things. So, looking over the whole history of the studio, what are your proudest moments?

Kei: The best thing is seeing how it has affected others. We have Schoolism students who are now real success stories – that's something you can't buy. It's the most rewarding thing. It's also wonderful seeing more and more artists joining together to create their own studios; seeing the art community become more independent, which is a really healthy thing.

Bobby: We've had many really amazing emails that bring us to tears. When we started there were no other online schools – none! Because of that, Schoolism had a positive effect on many people from all over the world. I remember when we were students, and someone told us you need 20 years' experience before you start a studio. Now things are so different.

Kei: There's no rule book. I remember when we first started, we self-published and we were ridiculed for it. People were asking why we did that – but we just wanted to put out a book, so we did. Luckily, nowadays those kinds of things are more well-received. If you want to publish your own children's or painting book, go ahead! It's great to see artists becoming more independent. I like to think we've shown that it's possible to stay independent and thrive.

What are your thoughts on formal education, and what path would you suggest to someone who wants to become a character designer?

Bobby: It really depends on the person, and in the end it's like anything – you are using your own money, so what do you want to get out of it? Education should be an investment. Ask yourself, how much it will cost and how much you expect to get in return. It's the best way to figure out if a university or course is right for you.

19-year-old me needed the structure of college. But I did go to school in Canada so it was considerably cheaper than some other schools. It depends on your other responsibilities, too. Right now, I wouldn't be able to commit, but I can do Schoolism classes in my own time.

A would-be student once asked me, if I had their college tuition – so around $200,000 – would I go to college, or would I do something else with it? My answer had to be, something else. I would buy a supercomputer, lease a beautiful studio to work in, and spend money on other learning resources. I'm not saying this would be right for everyone, but that was my answer in the moment. I think I would take $50,000 of that and make appointments with all the artists I admire, paying to speak to them for a few hours – think how much you could learn! Life is the best school, and actual school is only a chapter in the education of life.

It's been so inspiring to speak to you. Before you go, can you tell us a little about *Niko and the Sword of Light* – it's nominated for another Emmy this year!

Bobby: Yes! In 2016, *Niko* won the Daytime Emmy Award for Outstanding Children's Animated Program for season one, and is nominated again this year for season two. Unfortunately, Amazon have cancelled all their original children's programming so there won't be a season three. It started when we met up with an artist friend of ours and started talking about how we had both sold shows early on in our careers that never got made. We realized the iPad was around now (it had only been around for a couple of years) and we could make a story as an animated comic-book app, and make it with 22 minutes of animation, so producers would realize it could easily be a TV show. Amazingly, the app ended up being number one in its category in the App Store in 36 countries! We had loads of calls and decided to sell it to Amazon. Four of us artists started to create the show together, and very quickly

Rob Hoegee, the showrunner, came on board and wrote a beautiful extension of the world. It just took off from there and became one of Amazon's most popular kid shows. We didn't expect the Emmy at all, so much so that we didn't even go to the presentation show. We woke up the next day to hundreds of texts congratulating us!

Kei: And sadly, this time we can't go! The show was just so fun to create, and we did it in our own time, so it really had to be fun.

Bobby: It came from a genuine motivation to have fun and create something beautiful. That's one lesson we'd love for people to take away – to keep your motives genuine. Our studio came from a genuine motivation to just be artists, and the school came from a genuine motivation to find good knowledge. Your motives shouldn't be financial – that will come if your intentions are true.

"I like to think we've shown that it's possible to stay independent and thrive"

Opposite page: This issue's cover art by Bobby Chiu

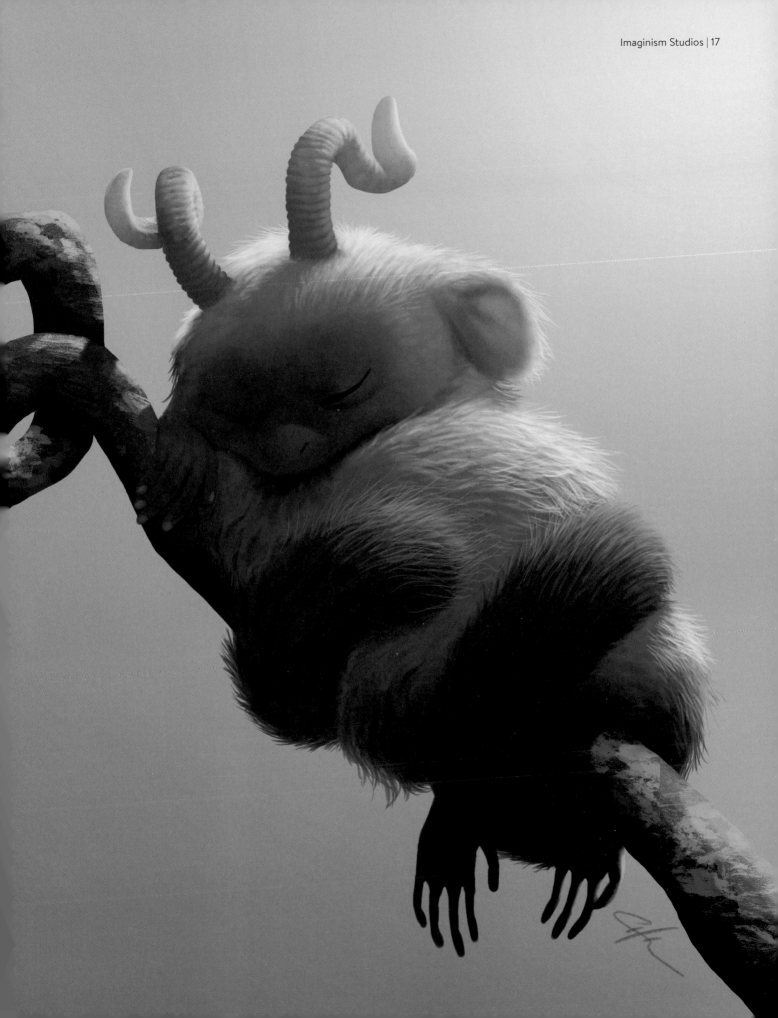

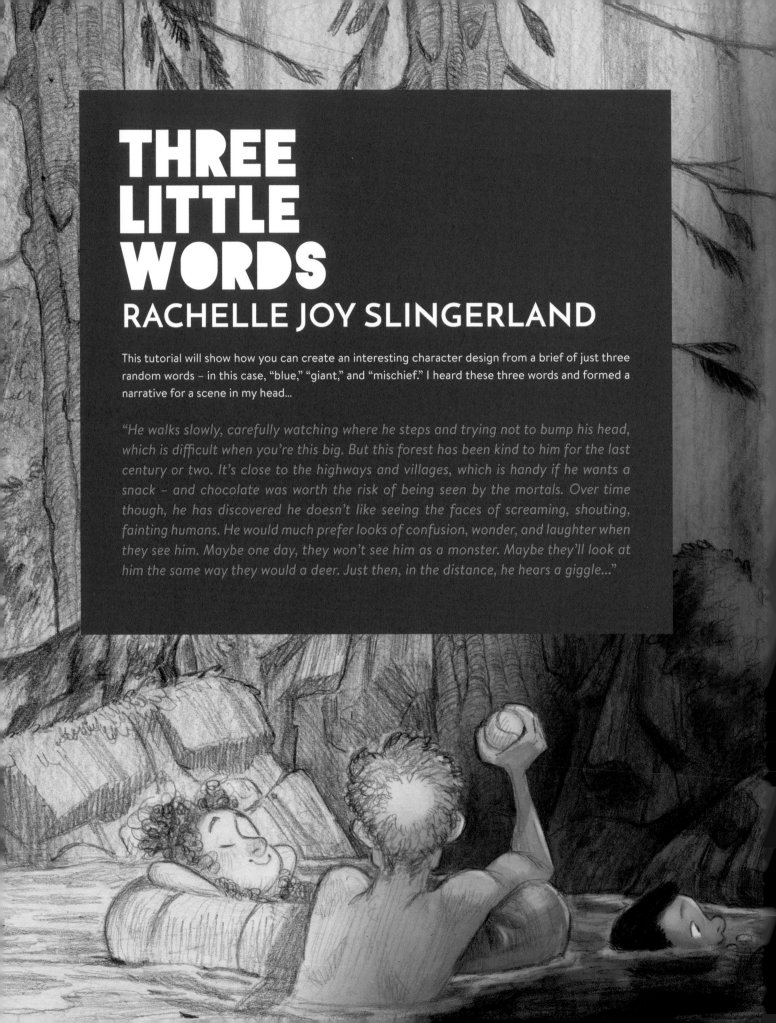

THREE LITTLE WORDS

RACHELLE JOY SLINGERLAND

This tutorial will show how you can create an interesting character design from a brief of just three random words – in this case, "blue," "giant," and "mischief." I heard these three words and formed a narrative for a scene in my head...

"He walks slowly, carefully watching where he steps and trying not to bump his head, which is difficult when you're this big. But this forest has been kind to him for the last century or two. It's close to the highways and villages, which is handy if he wants a snack – and chocolate was worth the risk of being seen by the mortals. Over time though, he has discovered he doesn't like seeing the faces of screaming, shouting, fainting humans. He would much prefer looks of confusion, wonder, and laughter when they see him. Maybe one day, they won't see him as a monster. Maybe they'll look at him the same way they would a deer. Just then, in the distance, he hears a giggle..."

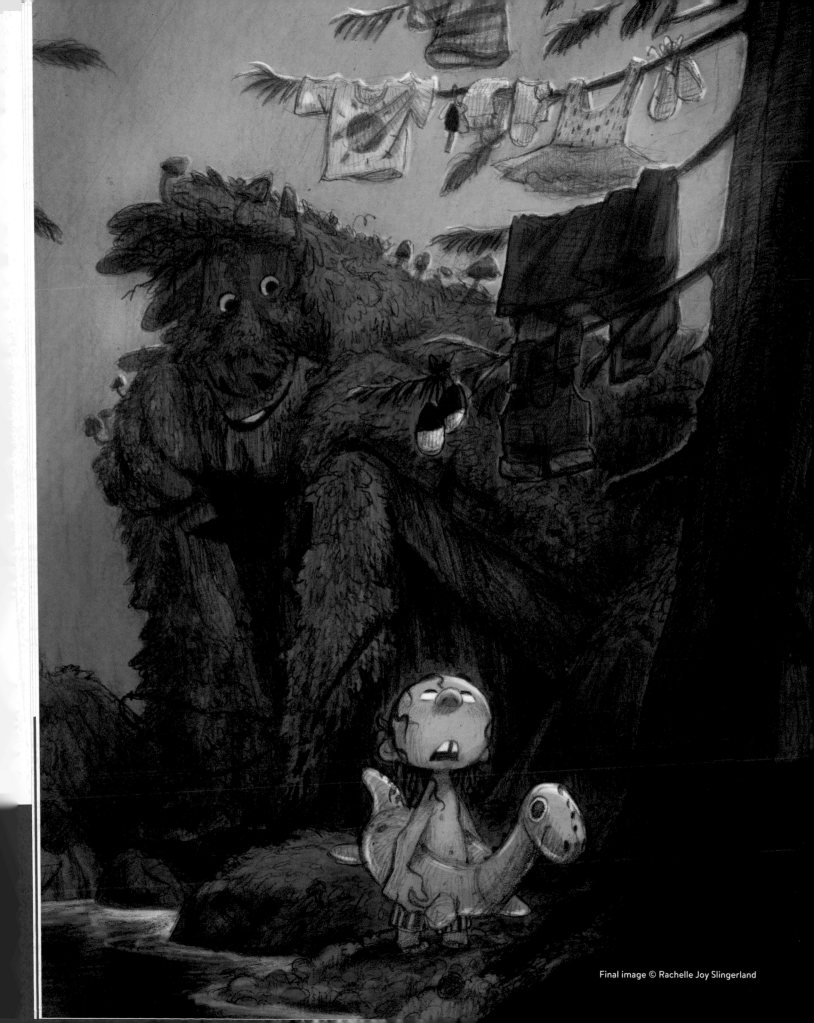

COLOR ME BLUE

Color can be difficult to master, and with this particular scene we need to make some delicate choices. Going back to the thumbnails can help you check the effect that color will have on your scene. For this particular image, we know that our giant needs to be blue, but we also need him to blend into his environment, so darker, muted tones of blue will be more suited than a bright cobalt blue.

Below: Color choices should be informed by the environment as well as your character

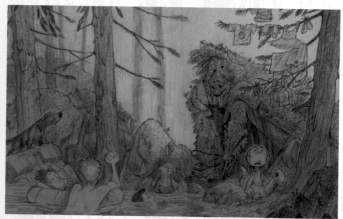
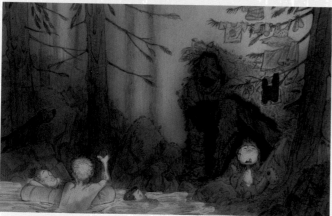
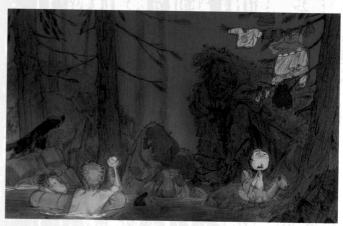

ASK A MATE FOR SOME HATE

Somewhere down the line you might get stuck. One thing you can do when you're not sure is call a friend. A second pair of eyes will shine light onto what you might have overlooked. Art is often seen as an individual accomplishment, but in order to grow you need other people. It's important to find fellow artists that you can call on, that you trust, and who know your strengths and your weaknesses.

THE MISCHIEVOUS GIANT

I love to create a narrative to accompany my final character designs and the scenes I create for them...

"Dad?" Little Felix calls as he looks up at his dangling shoes. A soft grumble rumbles through the forest. Sam the dog, who loves playing with his ball more than anything, spots the huge being in the trees, unnoticed by the humans.

"Uncle Ron!" cries Felix's brother, Jerry. "Look, even your keys are up there!"

Now Dad finally has their attention. In awe, they all stare up at their possessions decorating the big pine tree. Dad is about to grumble, but when he sees his children's scared eyes staring at him, he smiles. "Looks like the elves are at it again!" he says, cheerily. "Come on Fee, get on my shoulders and let's get our clothes back!"

Freya rolls her eyes, "Elves, dad... really?"

"Yes, elves. Did your aunt never tell you about the time she fell asleep in a fishing boat and woke up in the middle of a field? Or Grandpa, when he went to war, the enemy's cannon didn't work because they were overgrown and filled with moss – overnight!"

Snickering, Leif the giant watches the little mortals work together to get their clothes and keys back. He sighs happily when he hears an excited: "Mom will never believe this!"

They will never know, of course, what really happened.

"Elves", Leif snickers to himself, "they haven't been around for ages!"

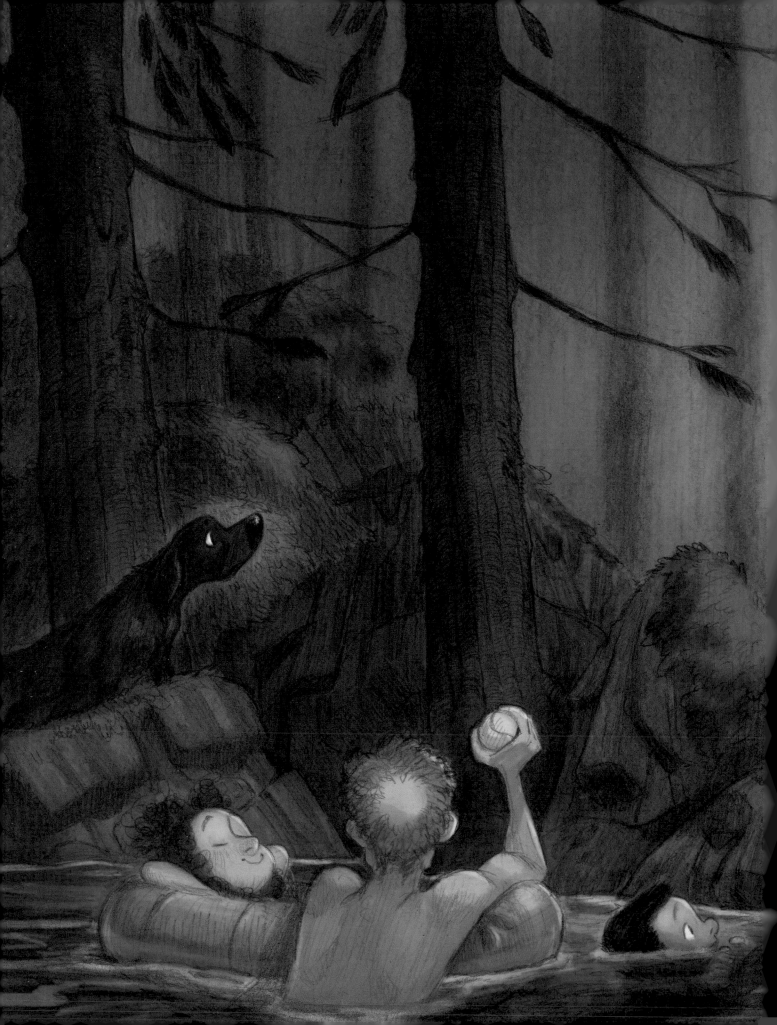

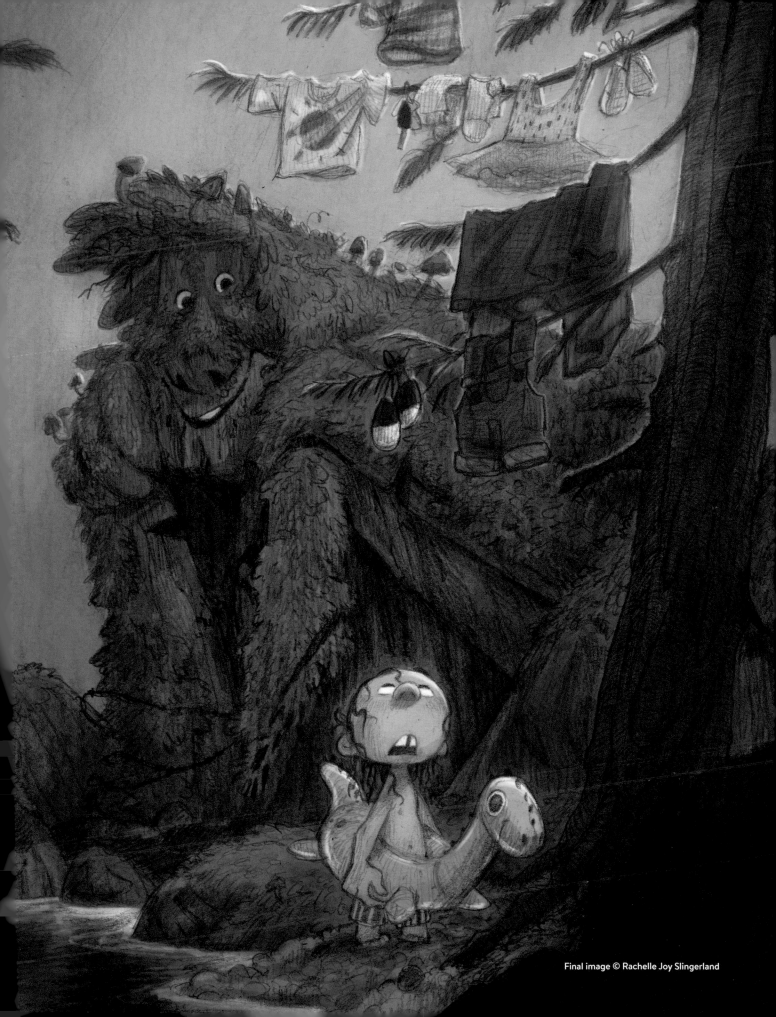

Final image © Rachelle Joy Slingerland

STYLIZATION AND MIXING MESSAGES

DIANA MARMOL

Adding unexpected stylization elements to your characters can be the thing that truly brings them to life. I created these particular designs with the aim of showing variety, to give you some helpful references and show how contrasting ideas can be used together to create something original. The initial sketch is shown alongside each final design, so you can see the difference that stylization can make.

FEMININE AND MASCULINE

A piece of advice you may hear a lot is "straighter lines represent masculinity and curved lines represent femininity." But this is the kind of generalized tip that can be played with and pushed when stylizing characters. This particular design is a female who likes to dress in typically "masculine" clothing, so I have combined rounded and straight lines to convey this style. As long as you keep good flow and balance within the design, you can successfully mix messages in this way.

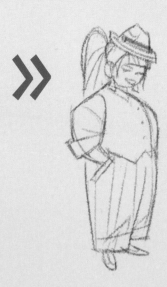

FINDING INSPIRATION

This next character is the opposite of the previous one – a man dressed in typically "feminine" clothing. It's important to use real-life references for designs like this, to explore fashion in the media to see if there is something you can take inspiration from. For this design, my reference is from a Korean period-thriller movie, in which the male characters' costumes were soft and flowy.

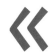

USING DETAILS

Sometimes you'll need to design a character that requires lots of detail to sell their personality – don't be afraid to include all of those details in your sketch. For example, this gypsy character needs lots of jewelry and layers of material to be convincing and represent her real-life counterpart. When you come to adding color, you can focus on the pose and action of the character, and unify any detailed areas from the sketch that could be confusing.

DOES POSE AND EXPRESSION MATTER?

Although it's ideal to explore storytelling poses later on, initially a straight standing pose can be enough to convey a character's personality. A standard pose can help you easily review the overall shapes and clothes. This same rule can apply to expressions – some characters rely on their expressions to show their character, but others do not. In this example, I did include a look of confusion on the boy's face, as this was needed to help portray his personality and age.

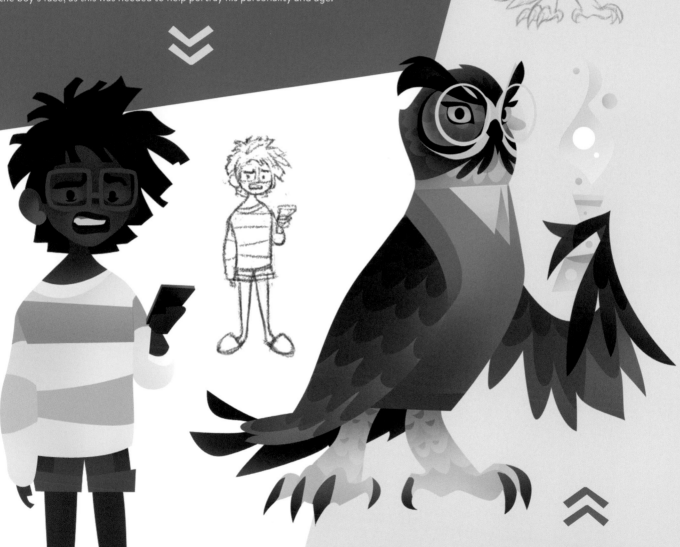

KEEPING TEXTURE SIMPLE

A set of small, repeated details can help to form an overall texture. In this case, the wings, head, and feet of the owl are made up of simple repeated feathers. Texture can also be added with varied simple shapes – this technique is used in the faces of the gypsy and the eye-patch-wearing man (opposite page) to add shape and interest. Texture can add soul to your creations, but don't overuse it – it's important to keep your design balanced with more-and-less textured areas.

FUSING CONCEPTS

One of the most interesting ways to stylize a character is to mix two seemingly opposing concepts. For example, this character conveys a mix of two concepts: "strong" and "elegant." I incorporated the two themes by using strong, oversized arms with narrow, elegant legs. You should never be afraid to mix contradictory ideas within a sketch – breaking the rules is often the path to innovation.

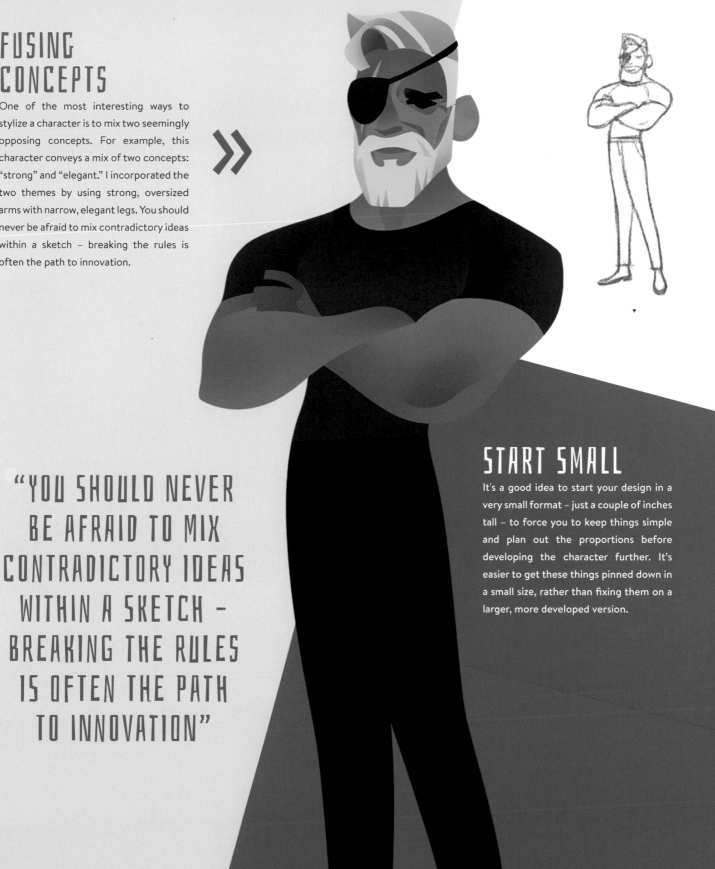

"YOU SHOULD NEVER BE AFRAID TO MIX CONTRADICTORY IDEAS WITHIN A SKETCH – BREAKING THE RULES IS OFTEN THE PATH TO INNOVATION"

START SMALL

It's a good idea to start your design in a very small format – just a couple of inches tall – to force you to keep things simple and plan out the proportions before developing the character further. It's easier to get these things pinned down in a small size, rather than fixing them on a larger, more developed version.

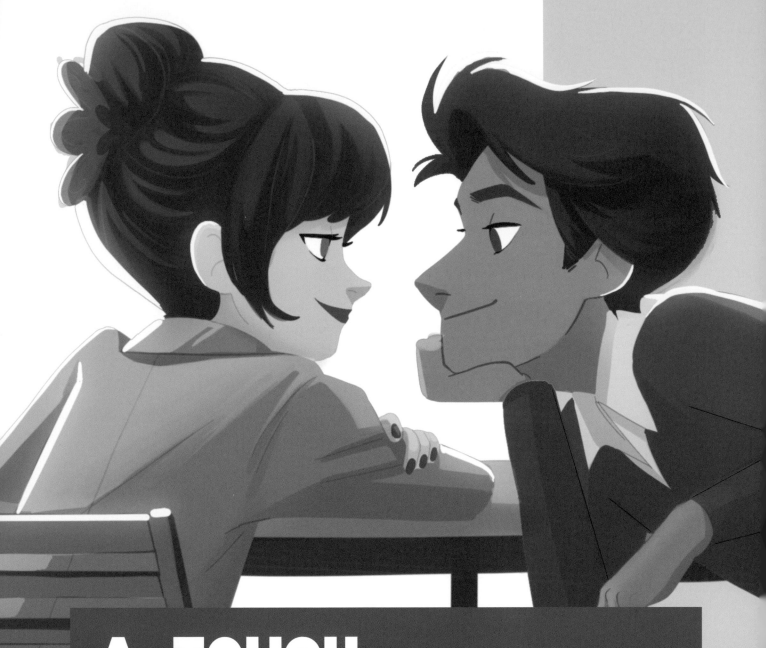

A TOUCH OF ROMANCE

NOOR SOFI

Showing character interaction is the chance to tell the story of a relationship to the viewer. In this tutorial, I'll be showing you how I approach it. I'll be showcasing a "romantic" interaction and focusing on digital artistic methods, demonstrating skills and tips that will benefit you when working with this medium. Specifically, we will look at how you can use layer effects to achieve more dynamic color schemes in your work.

The spark

When exploring an idea, it can begin with a simple list. The general theme for this piece is "romance" so everything needs to tie in with that. Making a list before you start to sketch can help ideas develop faster and narrow down the concept. It's also an opportunity to discover different possibilities for the theme that you might not have considered at first. If you find yourself running out of ideas, take the time to gather inspiration from movies, books, and photography.

Romantic interaction ideas:

- Couple on a swing
- Boy handing girl a flower
- Boy and girl running
- Couple watching movie
- About to hug
- Kissing
- Having dinner together
- Surprise kiss on cheek
- Falling in his arms
- Dancing together
- Couple on horseback
- Couple under umbrella

This page (above):
Create a list of all
the ideas that spring
from the prompt

Final image © Noor Sofi

The first look

Next, sketch out some quick thumbnail drawings of the favorite ideas from the list. The sketches don't need to be perfect, just enough to get an idea of what the piece could look like. This step is a good opportunity to see which of the ideas has the most visual and storytelling appeal. What might have seemed like a good idea in writing might not hold as much charm once drawn out. Equally, an idea that might have seemed weaker on the list could end up more engaging visually.

Reference

In order to create genuine, relatable designs, it's always best to draw from real life or reference images. When we're still learning, it's easy to make mistakes in anatomy of the human body in particular. Using reference helps us to draw more accurately and improve the level of our art. Finding the perfect reference online can be time consuming, but you can take your own photographs to use as well.

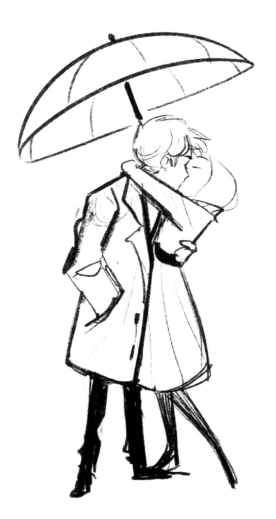

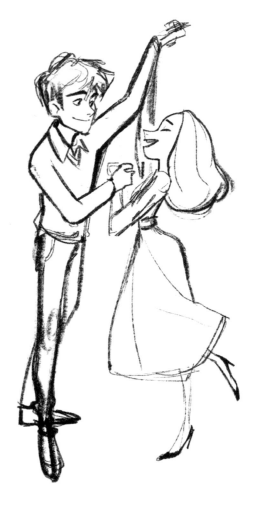

Opposite page:
Create quick thumbnails to take the written ideas to the visual stage

This page:
Refine the thumbnails to determine which works the best

Getting closer

At this stage, there may be multiple thumbnails that seem to work. In this case, take the time to develop the favorites into more defined sketches – doing so can help determine which to fully render. After developing these three sketches a bit more, I choose the sketch with the couple sitting at the table, because the chemistry between the two characters feels the most engaging.

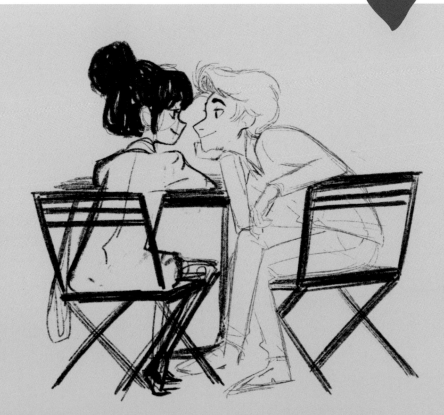

This page: Clean up the linework and do a final pass before coloring

Opposite page (top): Pick a color scheme that relates to the mood and personalities of the characters

Opposite page (middle): A shadow gradient creates visual weight

Opposite page (bottom): It's important to define the direction of the light source

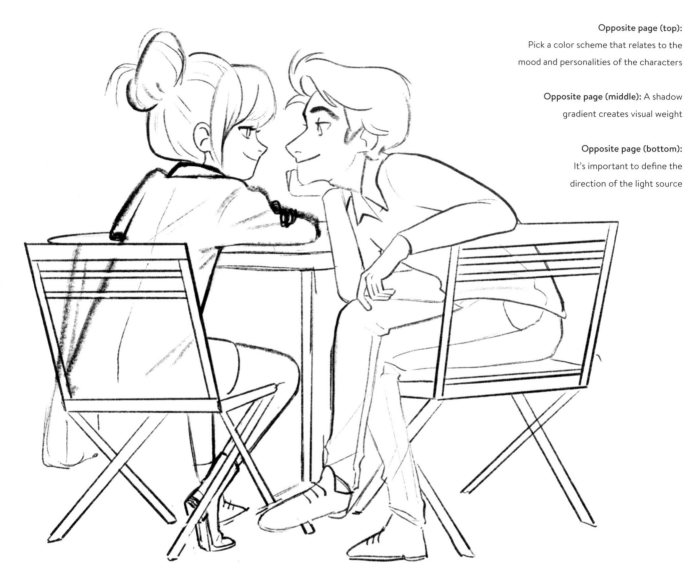

Refining the lines

After selecting the sketch to pursue, it's time to go in and add more definition to the linework. Even if I like the way something looks from the developed thumbnails, I always take the time to redraw it again – you'll be surprised at the improvements you can make by drawing over a sketch a second time. Refine the linework, clean up the edges, and make sure everything is in the correct proportion. I want this to be a lineless drawing, but the linework is still important as it will act as a guide when I start painting.

The color of love

Now it's time to paint in the flat colors. To do this, put the linework on low opacity and create a new layer underneath. For now, don't be concerned about lighting, just paint the general colors of the objects and characters of the piece. For this example, I choose earth tones to give a mature and intellectual vibe to the characters. If you need ideas for color schemes, look for inspiration in other art.

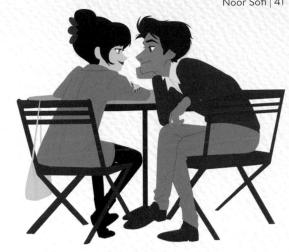

Adding weight

Now create a new layer and set the blending mode to Multiply – this will be the shading layer. Next, choose a color for the shading. For this piece, I choose a low-saturation magenta. I use either a gradient or airbrush tool, set to a low opacity, and create a gradient starting from the bottom and moving up, over the characters. This technique gives a sense of weight to the piece, as darker colors tend to feel heavier.

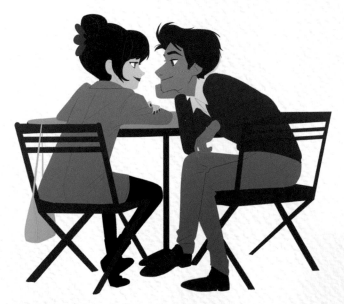

Shadows and light

The next layer will be used to define the shadow shapes on your characters. Create another layer set to Multiply and use a regular inking brush to start painting in the shapes. To make the shadow shapes more convincing, consider the light source and its direction. For this piece, the light source is the sun, coming from the top-left of the composition. It's important to design shadows to show the directional movement of the object the light is cast upon. For example, the light hitting the woman's hair casts shadows in the direction that her hair is pulled. The same technique is applied to the folds in the clothing.

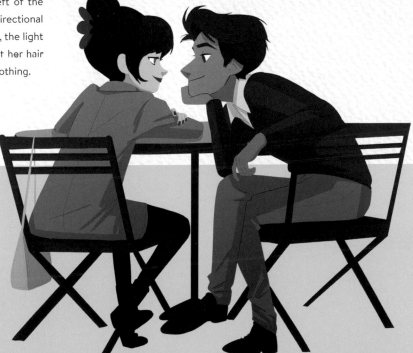

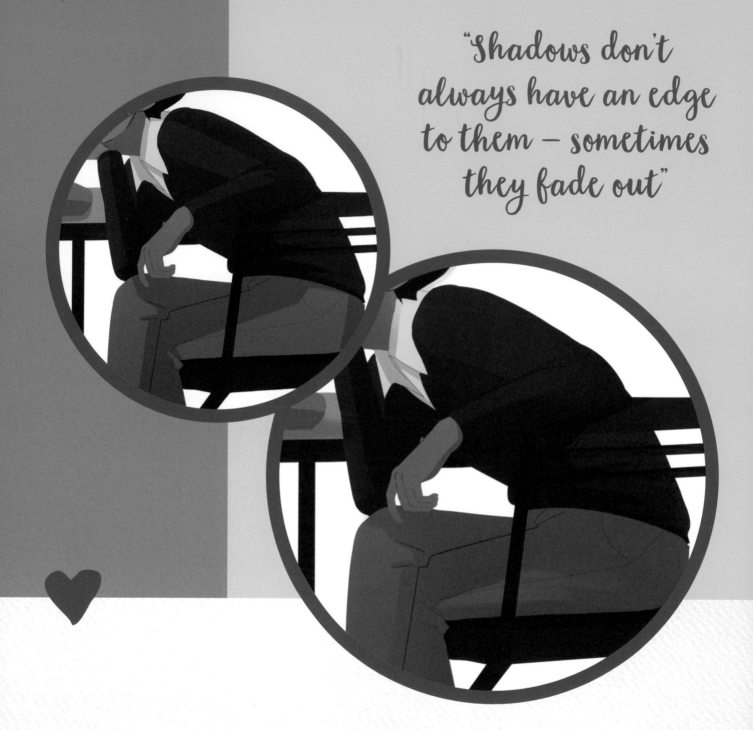

"Shadows don't always have an edge to them – sometimes they fade out"

Soft around the edges

Once the shapes of the shadows are defined, you might notice that some of the shadows seem a bit too hard-edged. Shadows don't always have an edge to them – sometimes they fade out. This usually happens on curved objects, or is caused by the relationship between the object and the light source (the further an object is from a light source, the softer the shadows are). For this piece, the shadows need to be softened where the characters' bodies curve, so I use an airbrush eraser tool to gently erase the edge of them.

This page:
The shadows are less distracting now the contrast is lower

Opposite page:
Take time to understand the direction of the light source

Layer effects

For this design's highlights and lighting, I utilized the Add effect, but you could use other lighting effects such as Color Dodge or Screen. Don't be afraid to experiment – when painting digitally, experimentation can be the thing that takes your piece to the next level.

Highlight of my life

Now it's time to add a highlight gradient, which will go from the top to the bottom, the opposite direction to the shadow gradient created earlier. Create a new layer, set it to Add mode, and use a color that relates to the light source – I choose a warm orange to represent the sun, and use a gradient or airbrush tool as I did for the shadow gradient.

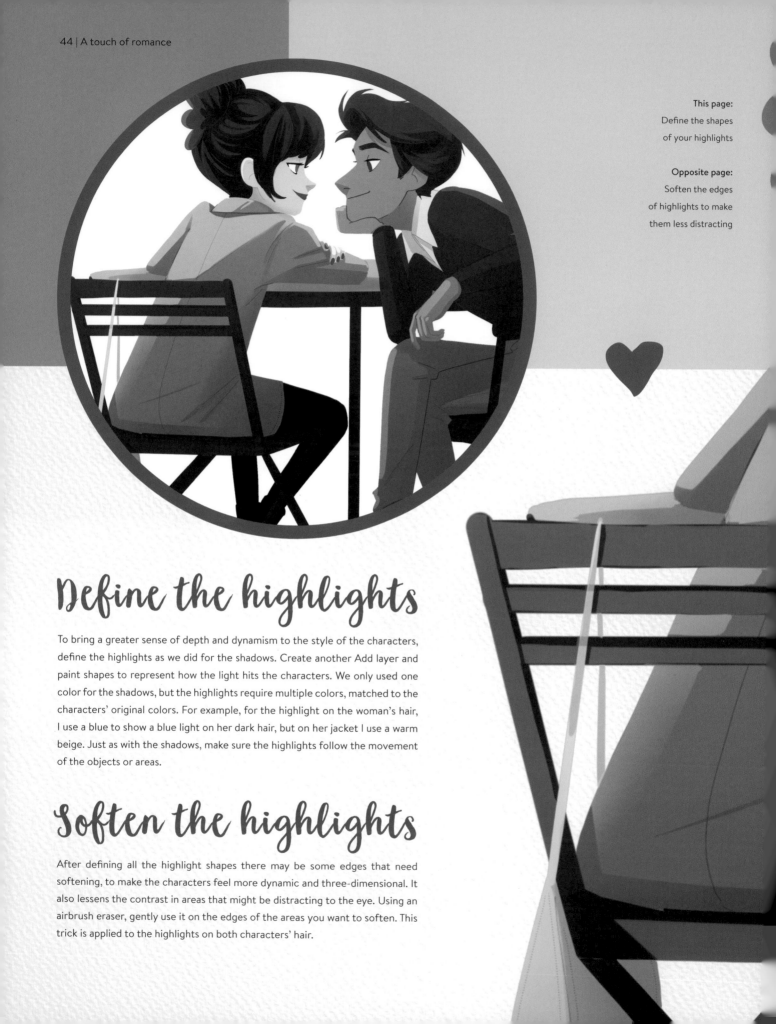

This page:
Define the shapes
of your highlights

Opposite page:
Soften the edges
of highlights to make
them less distracting

Define the highlights

To bring a greater sense of depth and dynamism to the style of the characters, define the highlights as we did for the shadows. Create another Add layer and paint shapes to represent how the light hits the characters. We only used one color for the shadows, but the highlights require multiple colors, matched to the characters' original colors. For example, for the highlight on the woman's hair, I use a blue to show a blue light on her dark hair, but on her jacket I use a warm beige. Just as with the shadows, make sure the highlights follow the movement of the objects or areas.

Soften the highlights

After defining all the highlight shapes there may be some edges that need softening, to make the characters feel more dynamic and three-dimensional. It also lessens the contrast in areas that might be distracting to the eye. Using an airbrush eraser, gently use it on the edges of the areas you want to soften. This trick is applied to the highlights on both characters' hair.

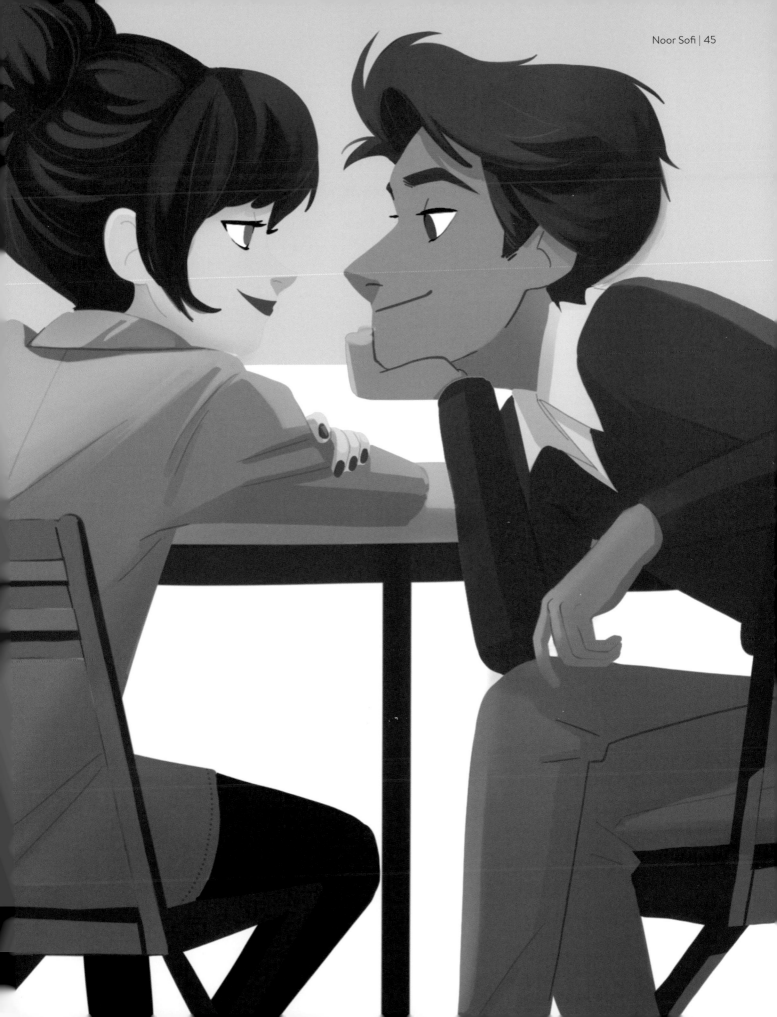

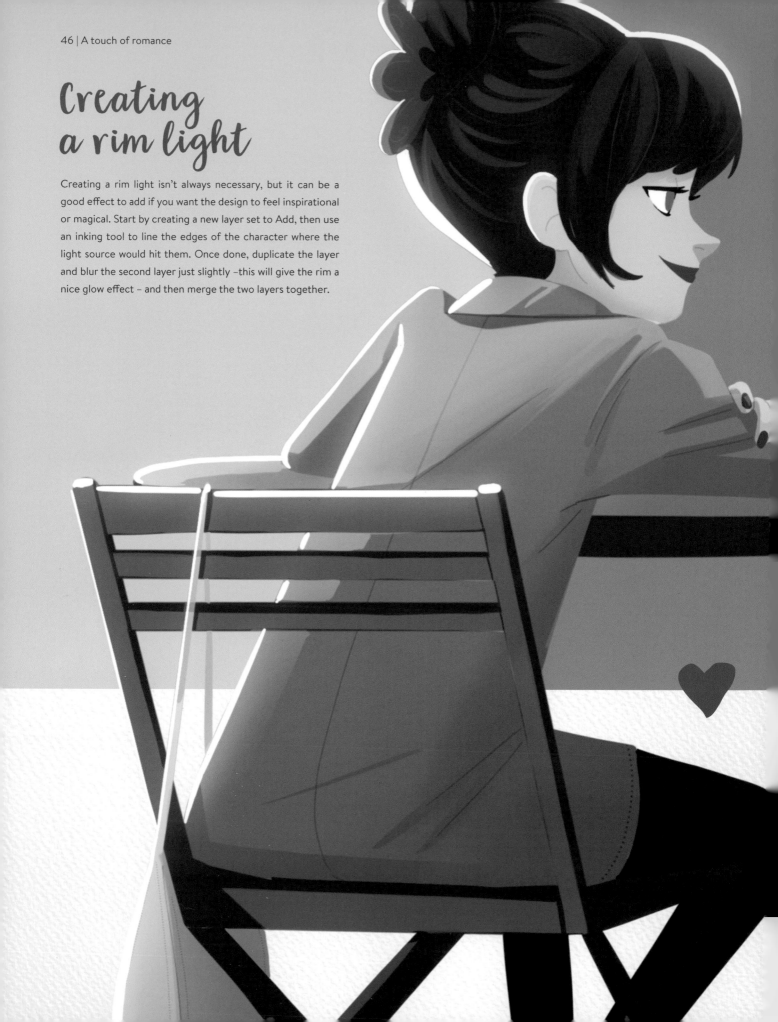

Creating a rim light

Creating a rim light isn't always necessary, but it can be a good effect to add if you want the design to feel inspirational or magical. Start by creating a new layer set to Add, then use an inking tool to line the edges of the character where the light source would hit them. Once done, duplicate the layer and blur the second layer just slightly –this will give the rim a nice glow effect – and then merge the two layers together.

Adding warmth

At this point in the design, we are starting to add elements to refine the image. I want to create a rich vibrancy to the characters to give them a sense of warmth. To do this, I create a new layer set to Overlay and select the characters' silhouettes, then I use an airbrush tool (set to a low opacity) and gently brush colors over the characters. For this piece, I use pinks and oranges in the highlighted areas, and blues and purples for the shadowy areas.

"I want to create a rich vibrancy to the characters to give them a sense of warmth"

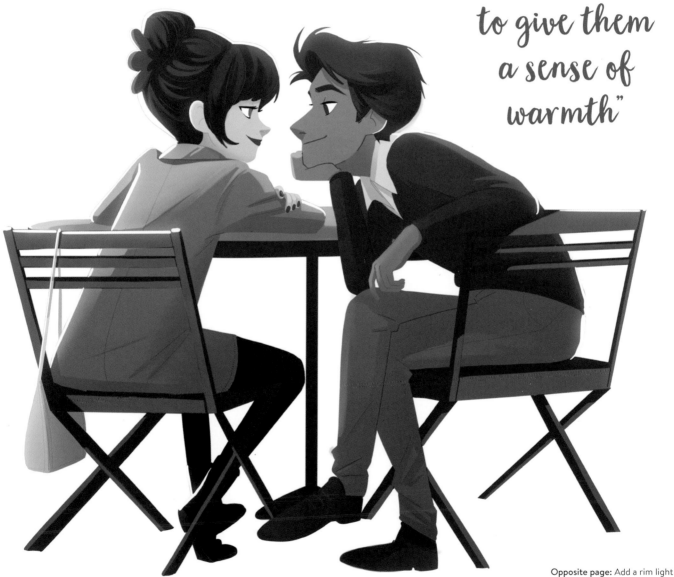

Opposite page: Add a rim light to create a sense of magic

This page: Feel free to experiment with colors, as different shades will create different moods

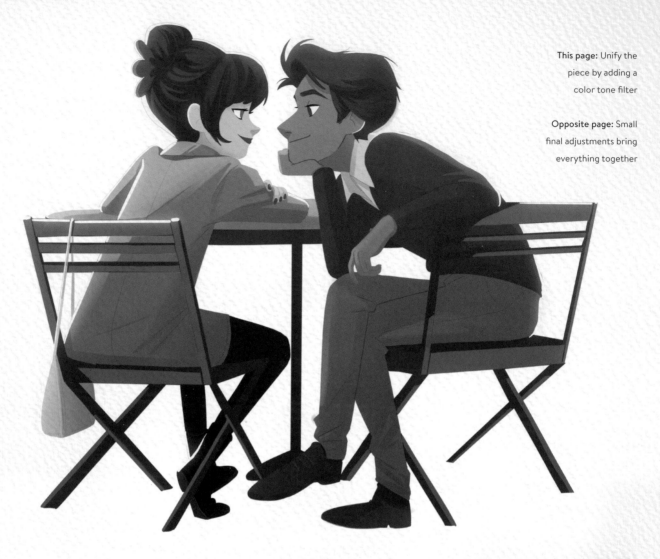

This page: Unify the piece by adding a color tone filter

Opposite page: Small final adjustments bring everything together

Total harmony

Adding a color filter on top of the piece can bring harmony and lightness, which will work nicely with the "romance" theme. To do this, create a new regular layer and select the characters and props, then fill the Select tool with the color tone you want to use. For this particular piece, I choose a light orange. Next, lower the opacity to a very low setting – for this piece it is set to about 13%. Covering the whole piece with the same color, set to a very low opacity, gives the whole image a sense of unity, as every aspect of the piece is affected by the same color.

A happy ending

Somewhere along the way, the multiple layering effects may have led to some of the original colors being lost, but that can be fixed. Final adjustments can be done by painting on a new layer on top of a piece, set to whatever effect suits your needs. Here, the man's hair has ended up looking too light, so I create another Multiply layer and darken it. I also add a drop shadow, make some color fixes, and redraw some of the lines to finish off the romantic piece.

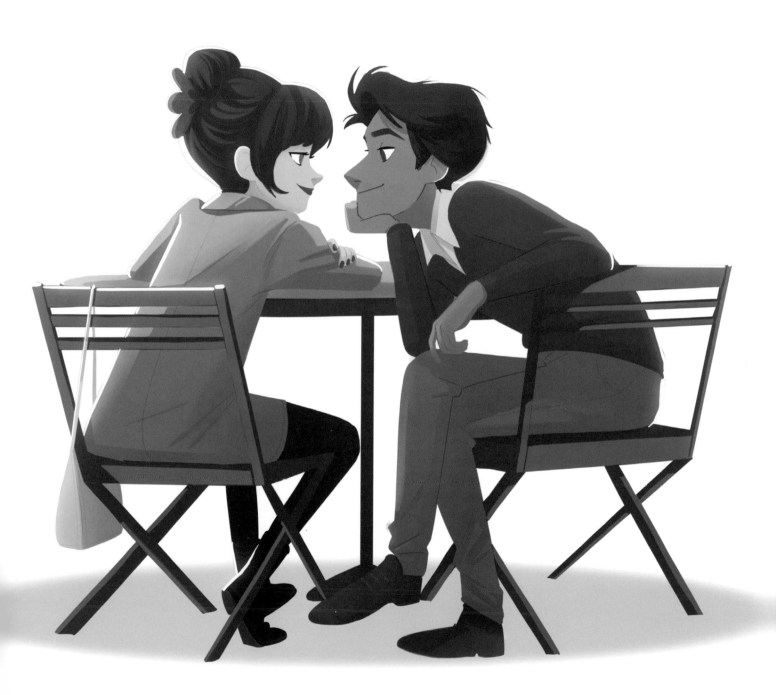

MEET THE ARTIST:

RAYNER ALENCAR

Rayner is a Brazilian artist who eats, sleeps, and breathes animation. He is currently the Production Designer at Miralumo, and we spoke to him about his role there, as well as what inspires him and why everyone should be getting into the animation business right now!

This page:

Verdinha

Hi Rayner, thanks so much for sharing your story with us at CDQ! For those readers that haven't seen your work before, can you explain a little bit about yourself, your creative journey to this point, and the style of art you choose to create?

Thank you so much for having me! It's a pleasure to talk to you guys. My love for animation started when I was just a kid. I must have watched Disney classics like *Aladdin* and *Beauty and the Beast* a thousand times, but of course, back then I had no idea of the craft involved in making them. To me they were "just movies" like any live-action ones – I didn't realize that artists actually created these characters and scenes from scratch. But like many of your readers I'm sure, my passion for drawing truly kicked in when I started watching anime series, like *Dragon Ball* and *Saint Seya*, on television in the 90s. I would pause the screen and copy them like crazy! From the age of around to 8 to 17, that was my main reference.

Then adulthood came knocking and I needed to start thinking about my future – I actually got my degree as a Legal Secretary, and that was the plan until I realized I could pay my bills through my art. But sadly, no company would hire me to draw those crazy Japanese characters. Even now, much of the general public in the Western world still don't really understand that aesthetic, which makes it hard to find work in that style. So, I had to look to Western productions instead to find a job. I focused my attention on artists like Glen Keane, Milt Kahl, Carter Goodrich, and Nicholas Marlet, among others. But I never actually stopped drawing my "anime" stuff, I just merged the skills I had into a more popular style. I transition a lot between types of production, working on both Western and Asian projects – something that makes my inner child really happy! I find that the more varied references you have and are able to mix, the more you can get some cool stuff going. I currently love my work as the Production Designer at Miralumo, where we're producing our own IP as well as providing services as a third party.

"MY PASSION FOR DRAWING TRULY KICKED IN WHEN I STARTED WATCHING ANIME SERIES"

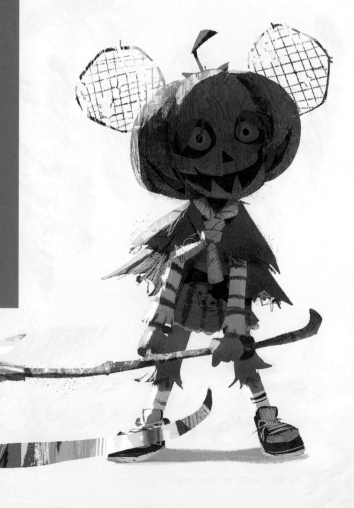

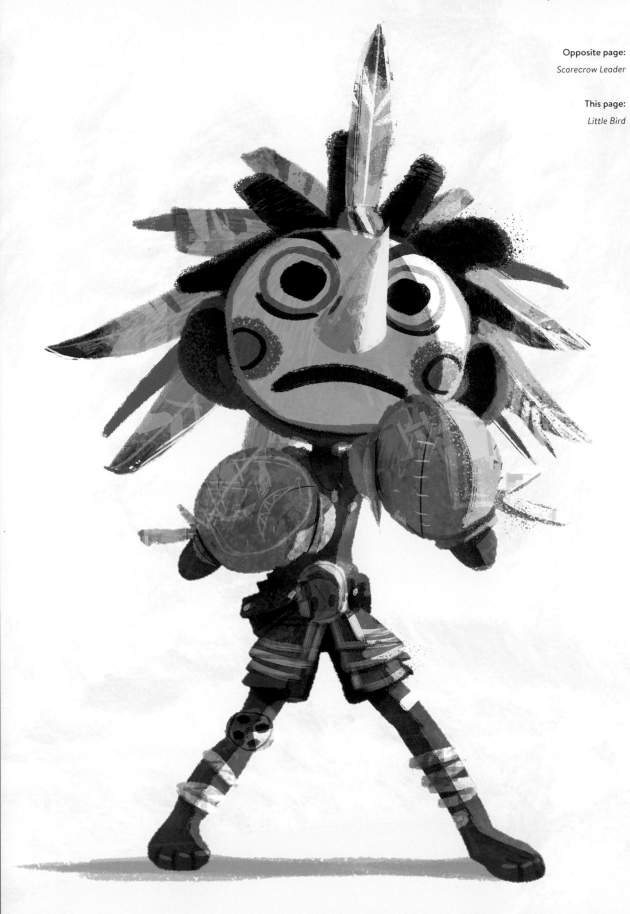

So, when your career plans changed, did you go to art school?

No, I didn't, I had no formal education in art – everything I've learned was through working. And sincerely, even now, I see formal education failing often. Every year art students all over the globe graduate with very little idea of how a real production works, what it takes to become a professional, and how much effort you really have to put in to succeed. People only really start learning when they start working. But, a disclaimer and important to say, this isn't true of ALL the art institutions, just the real majority in my experience. In Brazil, you can have your degree for free and so I think "okay, I understand why it might not be THAT good," but when I see that happening in other places where you have to pay crazy fees, I'm really shocked. You'll pay a LOT of money and still go out "into the wild" without enough skills to work.

Who or what would you say has provided you with the most inspiration over the years? And what is it about animation in particular that inspires you?

Asian animation has always been one of my main influences. Movies like *Tekkon Kinkreet*, *Tokyo Godfathers*, *Akira*, *Ponyo* and *Sword of the Stranger* are some of my favorites, as well as *The Incredibles* and *The Iron Giant* from Brad Bird, who is a director that I really admire. When it comes to individual artists, Satoshi Kon, Tatsuyuki Tanaka, Koji Morimoto, and Hayao Miyazaki are all heroes that will never leave my heart. In general, animation is what drives me. Most of the Brazilian artists that I know started creating inspired by comic books, but I was always about movies and animation. It's the MOVEMENT! I love movement. I love how animation can create fantastical physics that feel so "true." I still daydream about being

an amazing athlete who runs like the wind and jumps like Kuro and Shiro in *Tekkon Kinkreet*, or drives insanely as Lupin in the *The Castle of Cagliostro*. Personally, animation (especially 2D) is the only media that really makes me believe in the fantasy world of the characters, as they don't have to be ruled by physics in aspects such as light, movement, frame ratio, and more. The frame ratio used by Satoshi Kon would hardly fit a live action. Animation is about freedom, and the feeling of doing anything you can imagine, and that's why I'll always love it.

Opposite page: Scenes from Miralumo film project, *Beware of the Chicken*

This page: *X3 di Rua*

It sounds like you have the perfect job then! What exactly does your role as Production Designer for Miralumo entail?

I work side-by-side with the director to help establish the visual of the film – the broad, overarching look as well as the small stuff. We figure out answers to everything from "what do these characters look like?" to "which texture should we use on that carpet?" – and most importantly, work out how to make everything fit with the rest of the production. Most people will have seen the cool "concept" art that makes its way into art books, but the truth behind that is a lot of hard work. Many concept pieces have to be created to a high standard throughout the production, and a lot of problems need to be solved while converting 2D images into 3D.

Which project or production do you feel most proud of working on? And do you have any exciting plans for the future – new projects with Miralumo, or personal ones?

Working with Activision on a Triple-A game was a "bucket list" thing for me, as video games have always been a big part of my life. But I think my proudest accomplishment was becoming part of Miralumo and finally creating my own IP. The experience I gained working on *NAPO*, our first short film, was huge, and completely changed me as an artist. Every year you see older artists at Disney, Pixar, Dreamworks, and other huge studios quitting and starting on their own thing, and I'm so glad I have the opportunity to do that now instead.

We have loads of exciting projects coming up! We already have feature and animated series projects on pre-production, so stay tuned! Unfortunately, I can't say too much about them yet, but you can check out some teaser material on the Miralumo website.

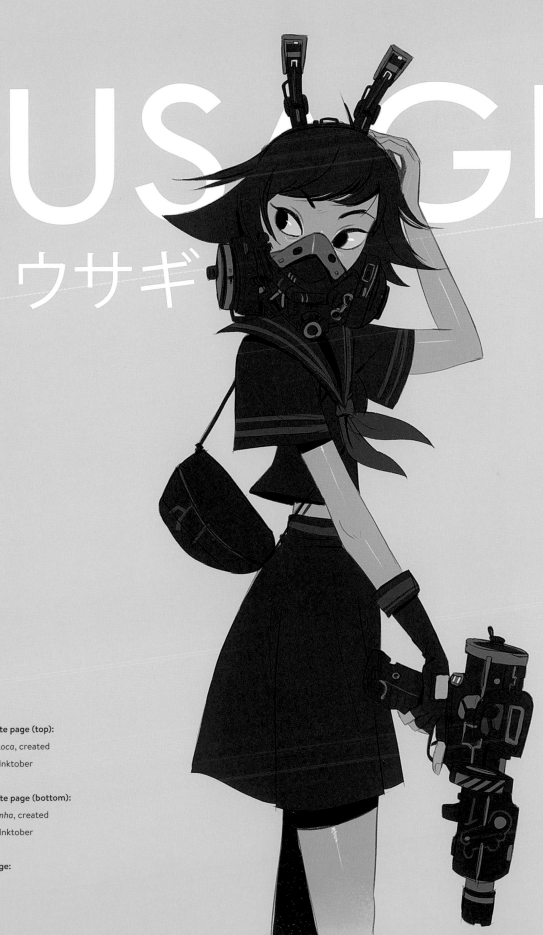

USAGI
ウサギ

Opposite page (top):
Magia Loca, created
during Inktober

Opposite page (bottom):
Porradinha, created
during Inktober

This page:
Usagi

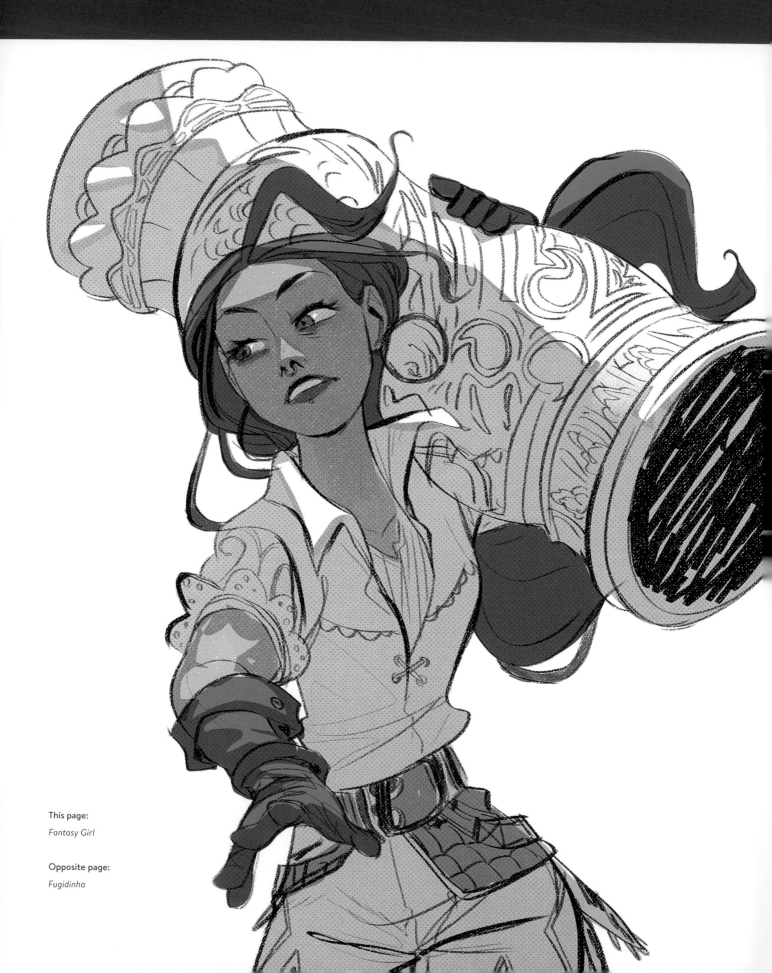

This page:

Fantasy Girl

Opposite page:

Fugidinha

"THE MORE YOU KNOW ABOUT WHO THE CHARACTER IS, THE MORE YOU CAN MAKE THAT CHARACTER SPECIFIC AND UNIQUE"

So to get a bit more technical, which stage of the character design workflow do you believe is most important in producing an effective final design? And which aspect do you find most enjoyable?

Absolutely the writing is the most important, or at least, establishing who the character is in your head. The more you know about who the character is, the more you can make that character specific and unique. Having constraints is often what drives our creativity; if you have free reign to do anything you want, the likelihood is you'll end up with something quite generic. Many beginners make the mistake of not taking the time to think about who the character is, or to do research, so they end up doing only what they know or remember from limited memory.

To be honest, I must say that I have no "favorite part" – I really love the whole process. I guess painting has parts that I don't find that amusing, like blocking the colors (oh I do hate blocking colors – technology help me!), but I do love when the colors are blocked out and I can start throwing lighting on it. I'm what you might call a "generalist" artist. I've heard that it's a bit unusual outside of Latin America, or Brazil at least, but here we have a culture of trying out everything in a studio when we're starting out, so I've already done animation, storyboards, character design, background design – you name it, I've done it! And I actually love that I've been able to get involved in every area and try things out.

Finally, do you have any advice for aspiring artists who need a confidence boost to get started?

The animation production industry around the world is on fire right now (in a good way!) – knowledge has never been within such easy reach, so there are learning and work opportunities everywhere. After all the Covid-19 disruption, I thought things might go downhill, but instead I'm seeing an increase in demand for animation – I think because so many live-action productions have been put on hold. Big players in the industry such as Disney, Amazon, and Netflix are in a crazy race to produce and deliver their animated projects, and I would put myself out there and say there are not enough animators in the world to supply the demand we have right now. So, if you're thinking "oh.. there's no way I can break into the industry, there are way too many talented people already doing it" – think again! If your only point of view comes from what you see on the internet, you're only seeing a really small portion of the reality. So, grab your brush, chalk, tablet, or whatever you use to create, and go get it! The animation industry needs you!

MAKING ★ MAGIC

KATE PELLERIN

This article takes you through the steps to building magical characters from scratch, and covers some techniques used in rendering. I also provide insight into rough shape design and the decision-making process of character building, and give some tips on how to treat a digital canvas as if it were a traditional one.

BREWING THE SPELL

When creating a magical character, it's especially important to play with different shapes and fun characteristics, to give them a fantastical look. One way to create new and interesting shapes is to choose a random thing, such as a strawberry, and merge it with human features. When you have fun experimenting with different shapes, it will show through in your design.

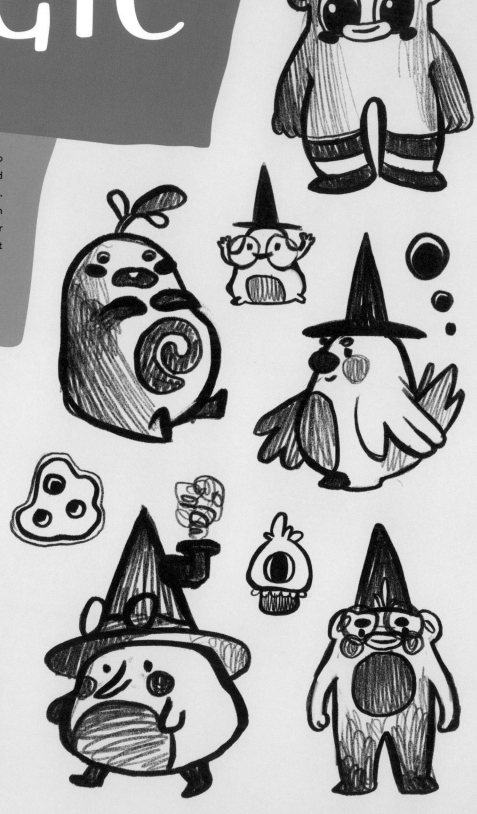

BASIC SHAPES

Once I've chosen a rough design, I like to break this down into a few large shapes. This helps me to quickly see if the character silhouettes are recognizable and interesting. Creating a few small compositions, using different colors per character, is also a good way to see if everything works well together as a scene. If there is a focal point in your piece, make it obvious by having the characters look or move in that direction, or by having items face the direction of the focal point. This will help lead the viewer's eye to the point of interest.

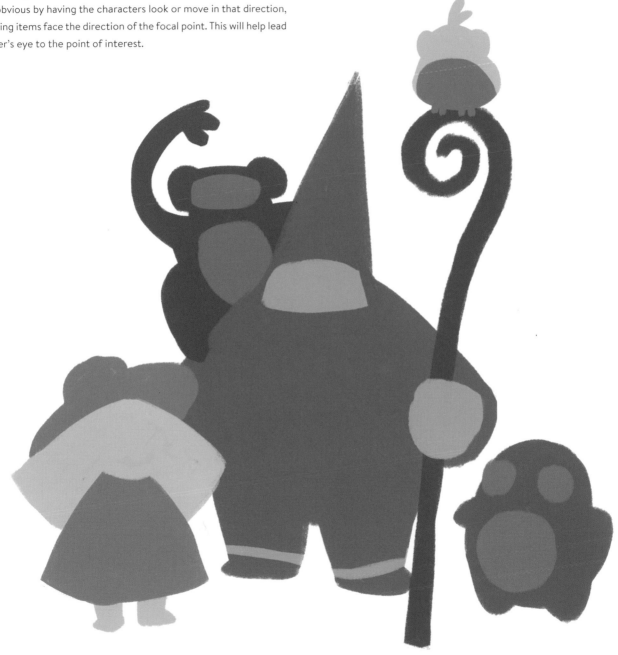

THE LOOSE SKETCH

When the composition is finalized, I create a layer on top of it to start sketching. There are many aspects to take into consideration, such as clothes, facial expressions, and movement. Loosely sketch your ideas and don't be afraid to make them weird – no idea is too strange when it comes to fictional characters.

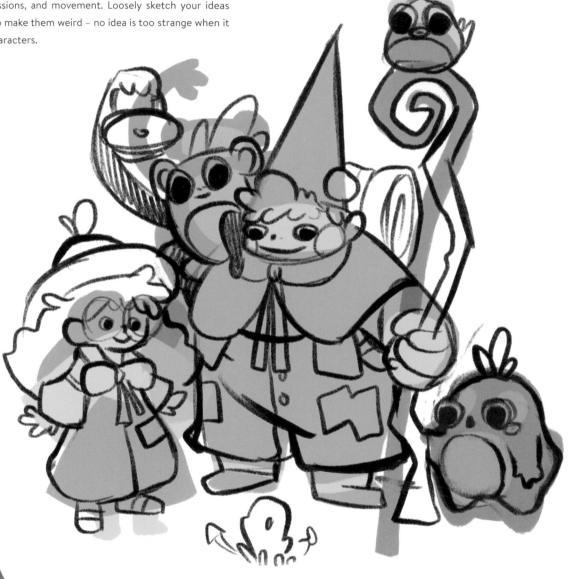

CHARACTERS HAVE FEELINGS TOO

A character can show their personality in a multitude of ways. A successful personality can be easily identified through facial expression, if they look kind, mean, or sad, but body language is also very important. Shy characters will be more closed in, whereas those that are more outgoing will have an open and confident stance.

THE PRETTY SKETCH

Cleaning up rough work to get it ready for coloring is important – take this opportunity to adjust or fix any problems with the design. Pay attention to whether your character is telling a story or not, and work the sketch until it does. Magical characters often include a lot of details to help tell their story, so make sure you add these.

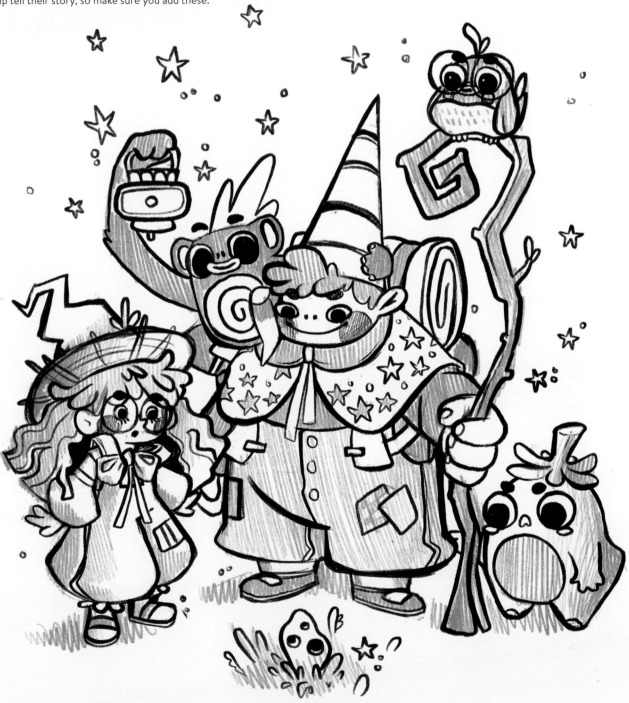

THE COLOR OF MAGIC

Colors can make a drawing come to life, especially ones with a magical theme. Try out many different color compositions and don't be afraid to use non-conventional color palettes. It's important to consider the mood and time of your final image; colors can give a lot of information about the characters and story, so being mindful of that will help greatly. Use a layer below the line art and create flat colors – this enables you to try different variations, and makes an excellent base for the rendering.

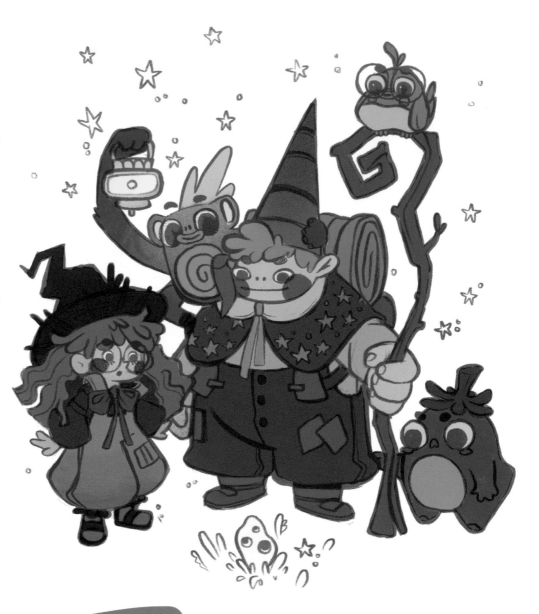

VALUES

Creating value can be tricky, but changing your drawing into black and white, or grayscale, will help you see whether the contrast is working or not. When shading, avoid using pure black or white to mix your colors, as this can appear muddy. Instead, use shades of the same color to maintain the vibrancy.

SCRIBBLING

There are many ways to render, but one that is particularly enjoyable for me is scribbling. This idea came from seeing how children draw, and wanting to bring that element to my work. Scribbling doesn't have any specific stroke, so it can be very messy and fun. Working with a small brush for details will help achieve crisp outlines, whereas larger brushes will give a broader finish.

SCRIBBLE TO THE FINISH LINE

As we finish up the design, we want to merge all layers together to create one final layer, and then treat it like a traditional drawing. To create depth with light and shadow, I like to pick a color from the base layer and scribble this in using a small sketching brush. When working with a certain hue, make sure to color-pick many different shades and highlights of that color; this will really help bring your characters, and the whole scene, to life.

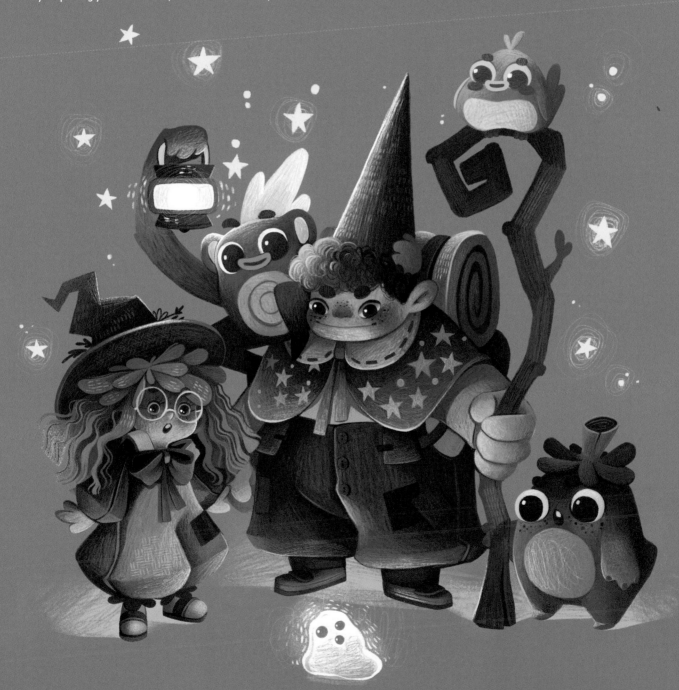

Final image © Kate Pellerin

CHARACTERIZE THIS:
ANGRY CLOUD
EMMA CORMARIE

I am going to show you how a character can be created from two simple words – in this case, "angry" and "cloud." First, it is important to define what each word suggests separately, then you can combine these characteristics to create a unique design. When the different elements are pulled together, they create an entirely new story.

GETTING EMOTIONAL - - - - - - - -

In order for a cloud to portray this human emotion, we need to give him human features. It's a good idea to use your own reflection for reference when conveying an emotion. For anger, the nostrils are flared, the eyes red and glaring, the mouth distorted, and the face wrinkled. These characteristics help sell the emotion, even in a cloud.

TEXTURIZING - - - - - - - - - - -

Adding texture is a fun way to make a character more appealing, and seem more "real." Because this particular character is a cloud, which come in many different textures, I can play with ideas and see which effect makes him look most angry. I settle on a slightly grainy texture, which emphasizes the unpredictable nature of anger.

BOILING OVER! - - - - - - - - - -

The emotion "anger" could be shown on many different levels, but I decide the cloud is angry to the point of steaming. Steam is blowing out of his nose, like a bull – he's brewing a storm! This is a commonly used signifier of anger in cartoons, and reflects the grainy texture used for the cloud's body.

THUNDEROUS VEINS - - - - - - - -

The idea of the storm theme seems a good one – linked to a real-life "angry cloud." So, I tie in more aspects of a storm throughout the cloud's body. I reflect patterns of thunder in his body, represented through popping veins, which help sell the emotion further.

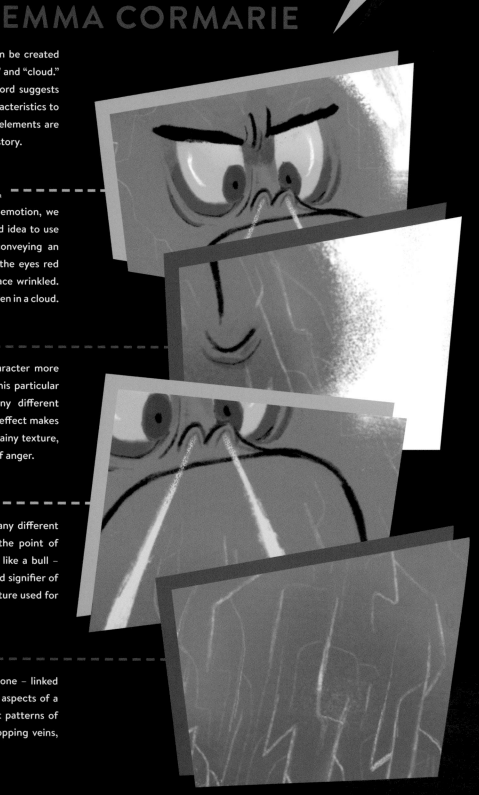

LIGHTNING STRIKES!

Finally, I add some bolts of lightning – a classic symbol of violent rage – below the cloud. This adds some dynamism to the character and helps our cloud appear overflowing with anger.

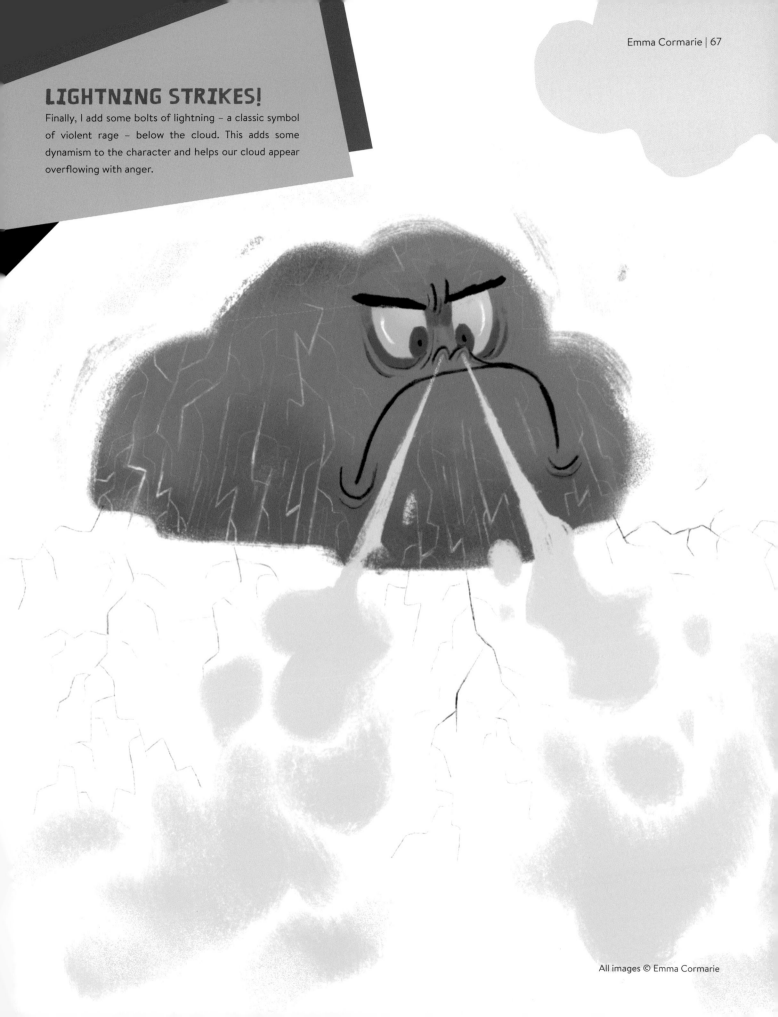

MEET THE ARTIST:

OONA HOLTANE

Character designer and illustrator Oona Holtane talks to us about working at her dream job in the animation industry, discussing her creative path up to this point and realizing that stepping out of her comfort zone has led to her greatest opportunities.

Hi Oona, thank you for taking the time to talk to us. Firstly, could you tell us a little about your artistic journey so far?

Thank you for this opportunity to tell my story. I hope that I can inspire other artists, like many have inspired me. I have always enjoyed the creative arts and was fortunate enough to grow up in an environment where creative modes of expression were encouraged. From painting to baking, from music to theater, the love for creating has always been prevalent in my life. As a child I adored animated movies – I would try to draw the VHS covers and pause the screen on our tiny television to copy the characters. I became sidetracked in high school, when I felt the pressure to pursue a career. All my friends began taking higher level English and science classes and working to get into a prestigious college. So, I followed along the same path for a good three years. Looking back, I'm grateful for this time as it acted as a driving force, leading me to the decision to risk everything and pursue a career in art instead.

I started university with the intention of becoming an illustrator, but I found myself gravitating toward film and animation instead. It wasn't until the second year that I realized I could make visual development into a career. I didn't want the illustrations I created to live on their own – I wanted my art to exist as part of a larger picture. I found illustration quite isolating at times, for someone who enjoys bouncing ideas off other people. I realized that instead of trying to do everything myself, I could combine forces with another person skilled in something I couldn't do. This led me to make friends through social media and start to work on collaborations. During this time, I experimented with fashion and editorial photography, and continued my illustration degree, but was also studying animation and thinking about how I could break into that industry.

This started what I call "the year of rejection" – but that's to be expected! I sent out my beginner's portfolio and looked through many "art of" books, sending out emails to the artists asking for advice. Some replied with feedback and suggestions for improvements and these rejections were blessings in disguise, because they forced me to grow as an artist. The following year I was accepted into the Disney Internship program, and that changed my life! One studio took a chance on me and helped to kick-start my career – something for which I'll be forever grateful.

Coming from a state school where no recruiters visited and no animation resources were provided, I thought it would be years until I broke into the industry. The fact that I didn't go to a traditional art school ended up helping me in many ways. I gained a well-rounded education and had the opportunity to take classes on psychology, specific cultures like Inuit and early humans, African art history, and even philosophy and logic. I always enjoyed fashion design and playing around with a sewing machine, so I began incorporating that into my art as well. With this added knowledge, I found that I could tell stories that connected with more people. Taking this interest in research and combining it with my love for animation and design, I found something to be truly passionate about.

This page:

Breakfast – a character design

Opposite page:

Acting – trying out different expressions for the character

"THE FACT THAT I DIDN'T GO TO A TRADITIONAL ART SCHOOL ENDED UP HELPING ME IN MANY WAYS"

You mentioned looking at "art of" books for inspiration. What books would you recommend for beginners to help teach and inspire?

Some of my favorite books focusing on technique are *Drawn to Life: 20 Golden Years of Disney Master Classes* (a book of lectures from inspiring long-time Disney animator Walt Stanchfield), *The Animator's Survival Kit* by Richard Williams, and *Framed Ink: Drawing and Composition for Visual Storytellers* by Marcos Mateu-Mestre. I also find autobiographies and self-help books to be incredibly motivating when I'm in a creative slump. The two I return to the most are *The Art of Learning* by Josh Waitzkin and *Creative Confidence* by Tom and David Kelley.

I love fine art and find that it often influences my design choices. My favorite fine-art

books are *Van Gogh: A Retrospective*, *Andy Warhol: Seven Illustrated Books*, and *The Ultimate Picasso*. When it comes to animation-centered *Art of* books, *Sanjay's Super Team*, *The Incredibles*, *Ratatouille*, and *Into The Spiderverse* are all incredible to own. There are so many amazing art books out there!

Your illustrations use unique color palettes and feel very expressive. Was this something that came naturally to you, or did you learn it along the way?

Color has always resonated with me. Even as a kid, I gravitated toward vibrant colors, and it showed in my fashion choices! But this attraction to color only started to come through in my art once I learned about color theory and psychology. I started to understand that emotion and color go hand in hand. I find

that I never use colors from other art – I always prefer to look to nature and the real world. Exaggerating these colors, and pushing them to reflect my personal view of the world, allows a more expressive and individual perspective to shine through. My style has changed over the years – when I started out, my drawings were hyper-realistic. This helped me learn the foundations, but in the end I found it incredibly draining. It took a long time to break down this need for perfection and to allow myself to be freer with my design choices.

This page: A model sheet for a blue-tailed skink – drawn in colored pencil on paper

Opposite page: *Lion* – pastels and colored pencil on paper

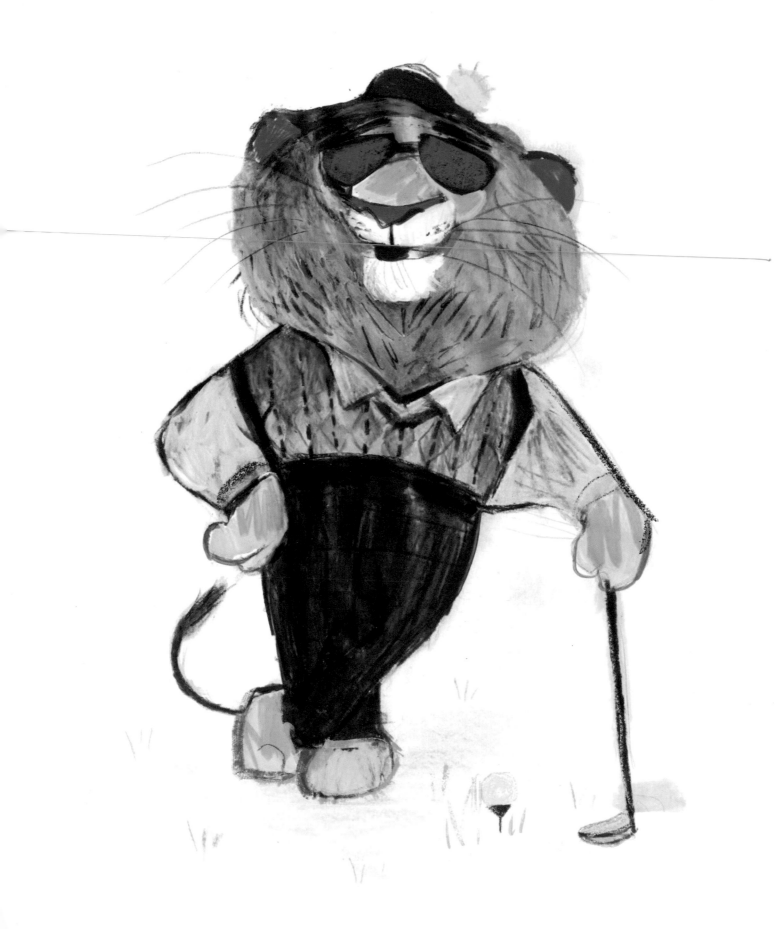

Do you prefer to work digitally or traditionally – and what are your favorite mediums to work with?

To be honest, I find it difficult to stick to one medium, or even to one visual style for that matter. There's something so creatively fulfilling to bounce around materials, never using one for too long – I find I can solve creative problems more easily if I tackle them with a new medium. But drawing with colored pencil will always be my favorite. Something about putting pencil to paper feels so satisfying, and having a tangible piece of art makes it feel "real." However, working digitally provides the undo button and more opportunities for trial and error, so there are definitely benefits to both methods. Digital makes working more efficient, taking away the difficulties of traditional media – but it can also take away the happy accidents. If I'm on a tight production schedule, I will start drawing traditionally, scan it, then add color and finalize digitally. When working digitally I still like to ensure a "traditional" quality – when something is too perfect, I feel like it loses some of its "life."

This page: *Tanuki* – an exploration in colored pencil and digital media

Opposite page (top): *Story Moments* – digitally created character scenes

Opposite page (bottom): *Monkey*

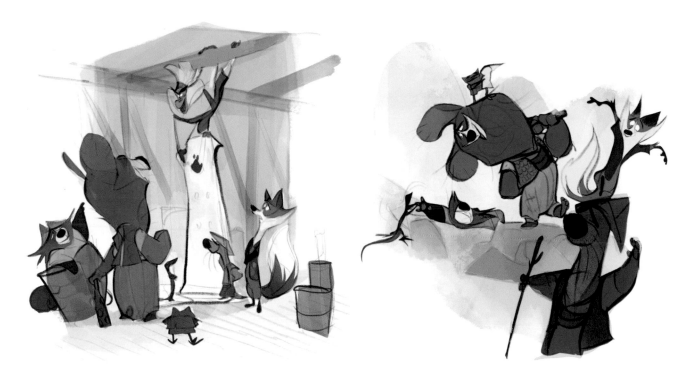

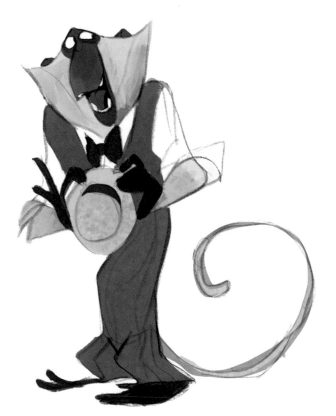

Your characterized animals are really fun! Where do you find inspiration for these guys?

Thank you so much! I grew up drawing animals copied from animal reference books and encyclopedias, and always found that I automatically gave each animal a personality. I think this stems from a game I would play with my siblings – we'd go through these books and create something for each animal to say. I was also a huge fan of the early Disney movies, especially the ones with animals in, so inspiration came from there, too. I like the challenge that comes with designing animal characters. Each species has a different anatomy and different behaviors to research, which opens up many opportunities to create interesting designs. I enjoy drawing these individual personalities and expressing their story through poses and action. I like to research the movement of the animals before putting pencil to paper, because it really impacts the personality that comes across. All these challenges bring me inspiration and help to make my animal designs fun.

Who do you consider to be your greatest inspirations?

The list is endless, but my mother has been one of the most motivating people in my life – I also get my impeccable taste in color from her! One of my top influences, in art and also life, is Andy Warhol. The way he was so bold and unapologetically himself, it's inspiring. There are many fine artists and graphic designers I admire, such as Gustav Klimt, Egon Schile, Picasso, Kandinsky, and Peter Thaibaud. And directors like Alfred Hichcock, Wes Anderson, Kurosawa, Brad Bird, and Pete Docter are why I want to work in film. When it comes to animation, artists like Tony Fucile, James Baxter, Glen Keane, Milt Kahl, Lou Romano, Mary Blair, Don Shank, Matt Nolte, Chris Sasaki, Daniela Strijleva, Joe Moshier… the list is endless!

You were an intern at Disney Feature, a character designer at Illumination Mac Guff, and you're currently working on a Netflix project. What does your day look like in these roles? What kind of projects do you work on?

I feel like every production I've worked on has been very different. Working as an intern, I had the opportunity to collaborate with some amazing artists and gained a lot of hands-on experience. However, my time at Illumination and now at Netflix has been all from my desk at home, so my routine is a little different. I usually wake up around 7:30am and begin work at 8:30am. When I work from home, I like to have a longer break or two shorter breaks in the middle of the day. I use this time to exercise, have lunch, and catch up with friends and family. Since I work two hours ahead of LA time, I have to stretch out my workday to fit in meetings and directors' rounds. Sometimes I pinch myself because I'm doing what I love for a living and working with some of my heroes. I love overcoming challenges, so when an art director or production designer assigns something I've not done before, or something seemingly boring, I like to find a fun way to work around the problem. Something I try to keep in mind is to always be open-minded and never back down from a challenge.

What's your secret to staying motivated and focused on your goals?

I find I need to regroup often. I keep sticky notes on my desk and around my room to remind myself why I do what I do. I'm naturally a little scatterbrained, so I have learned to write one or two "to-do" lists each day. Having specific goals and crossing things off a list helps me stay focused throughout the day, even if it's a small note to "go for a walk." I'm an organization nerd so I love planning things out and writing out my thoughts whenever I feel low. If I'm feeling really unmotivated, I take a step back for a while to take my mind off of my work. Motivation is rarely consistent – I find that I go through dips and phases where I feel burned out. Passion is one thing, focus is another.

I learned that productivity doesn't come from working constantly – it comes from balance. If we are constantly working and don't give ourselves the time to do anything else, it makes sense that we become tired. You need an intake of multiple experiences to gain inspiration. Working at a desk and never taking time to live outside often leads to stale ideas and resentment toward something that began as a passion. I find that my ideas come from life experience, the people I meet, the places I travel, the movies I watch, and the books I read. Being open to more experiences and pushing outside my comfort zone has led me to some of my favorite moments in life, and most (if not all) of my creative breakthroughs.

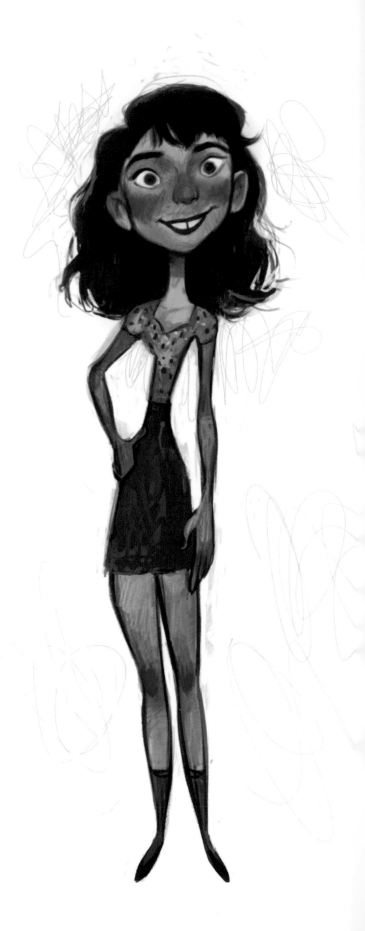

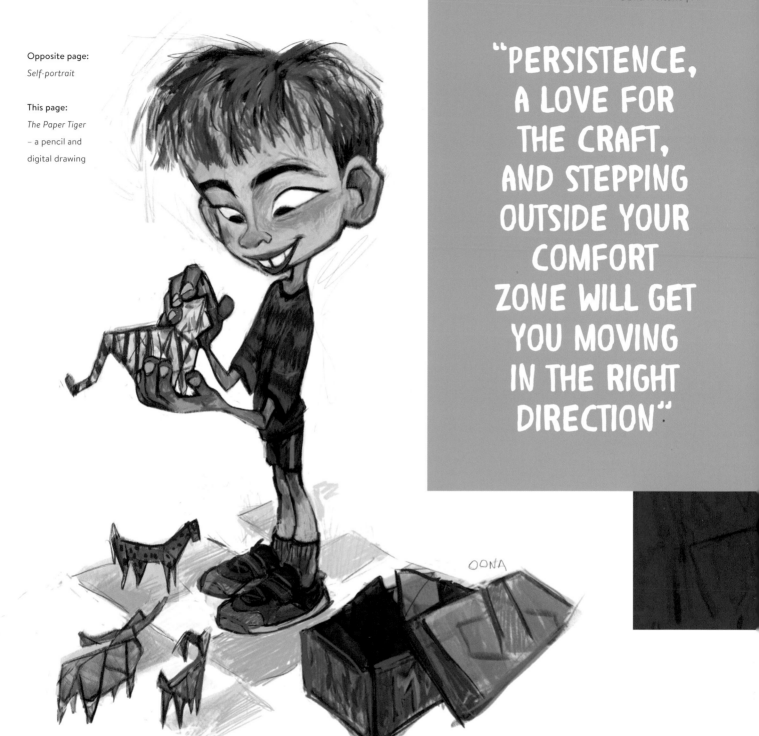

Opposite page:
Self-portrait

This page:
The Paper Tiger
– a pencil and
digital drawing

"PERSISTENCE, A LOVE FOR THE CRAFT, AND STEPPING OUTSIDE YOUR COMFORT ZONE WILL GET YOU MOVING IN THE RIGHT DIRECTION"

What advice can you give to young people out there who want to break into the industry?

Don't give up. You don't need to go to an art school or live in the right place to find a job in animation. Realize that everyone's path is different – there is no one right way to break into the industry. Persistence, a love for the craft, and stepping outside your comfort zone will get you moving in the right direction. Failure along the way is inevitable but doing what you love for a living, and being able to contribute to such a great industry, is worth the hardship.

THE GALLERY

In every issue we reach out to artists who specialize in character designs and character-based artwork to feature in our magazine. This issue features the work of Maya Lior, Sarah Beth Morgan, and Meggie Johnson, whose unique and charming designs we hope inspire and invigorate you.

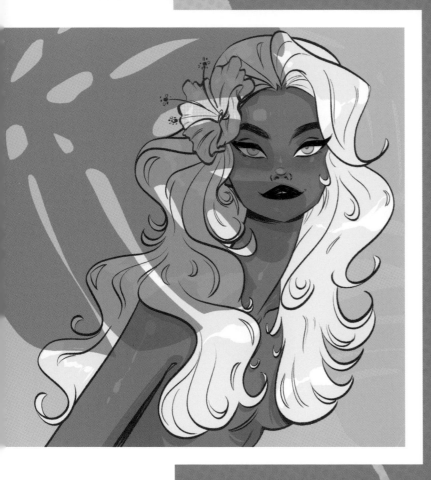

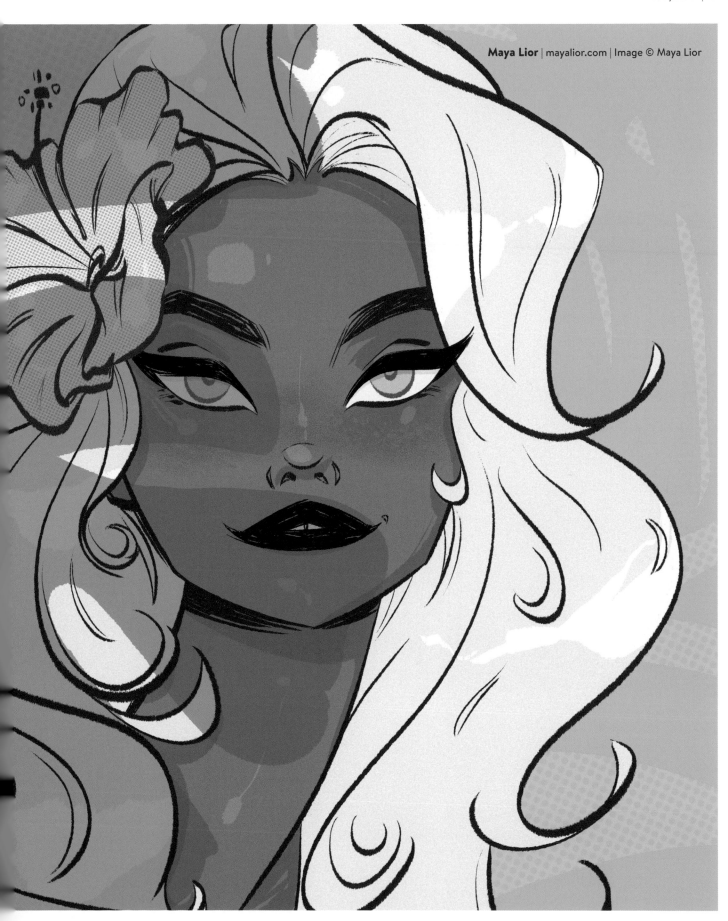

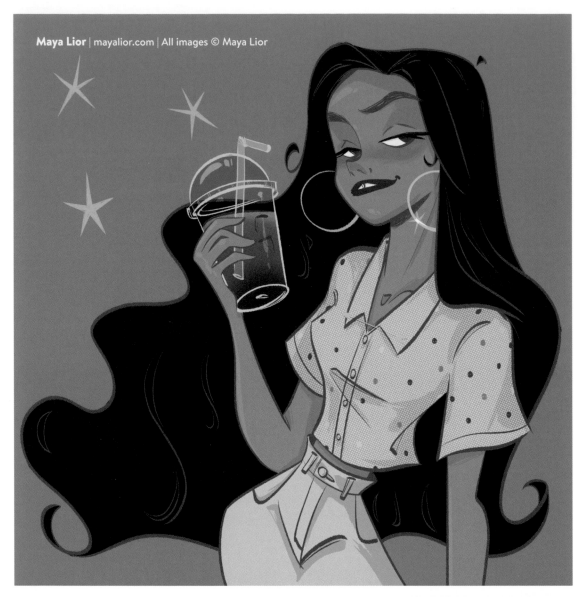

MAYA, ORIGINALLY FROM ISRAEL BUT CURRENTLY LIVING AND WORKING IN UPSTATE NY, IS A CHARACTER AND PROP DESIGNER FOR TV ANIMATION. HER PREFERRED TOOLS INCLUDE PHOTOSHOP AND PROCREATE, WHICH ALLOW HER TO PLAY WITH TEXTURED BRUSHES AND LAYERS TO CREATE UNIQUE GRAPHIC LOOKS. SHE IS PASSIONATE ABOUT USING LINE WORK AND BRIGHT COLORS TO INCORPORATE MOVEMENT IN HER DESIGNS.

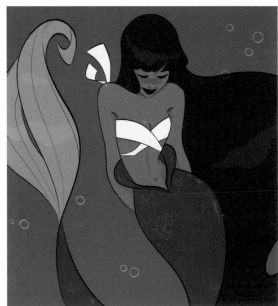

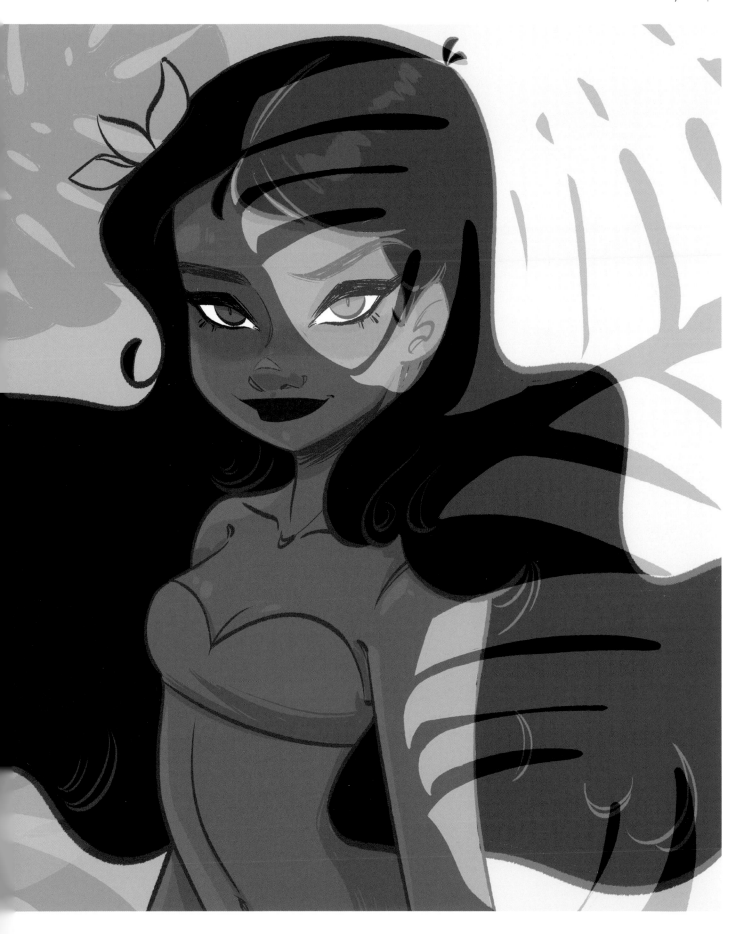

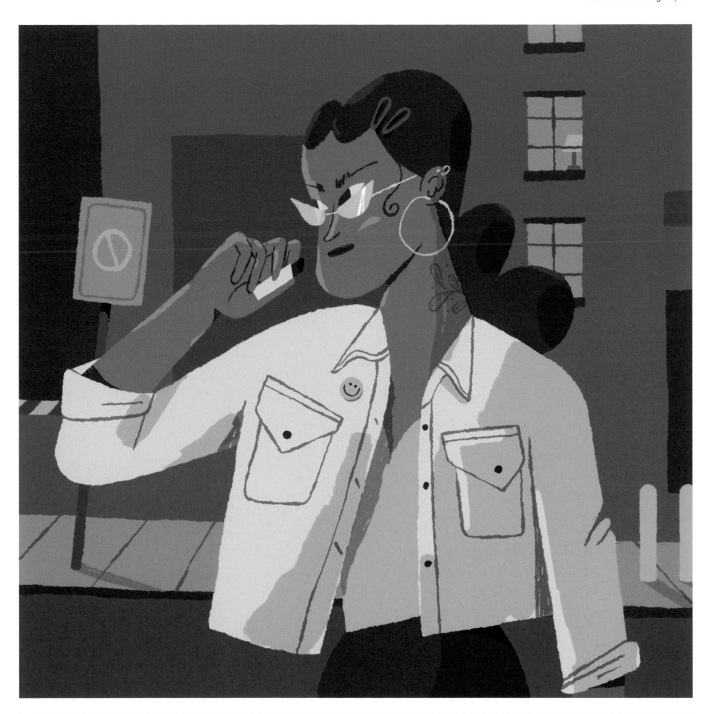

SARAH BETH IS A FREELANCE ART DIRECTOR, ILLUSTRATOR, AND ONLINE EDUCATOR BASED IN PORTLAND, OREGON. SHE ENJOYS DIVING HEADFIRST INTO PASSION PROJECTS, ADVOCATING FOR WOMEN IN THE INDUSTRY, AND LISTENING TO BAD MUSIC (HER WORDS NOT OURS).

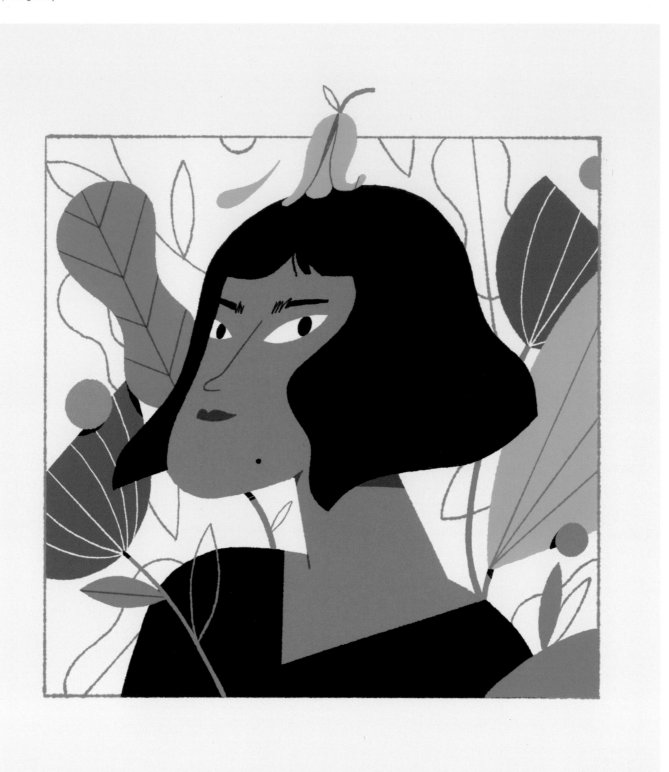

Sarah Beth Morgan | sarahbethmorgan.com | All images © Sarah Beth Morgan

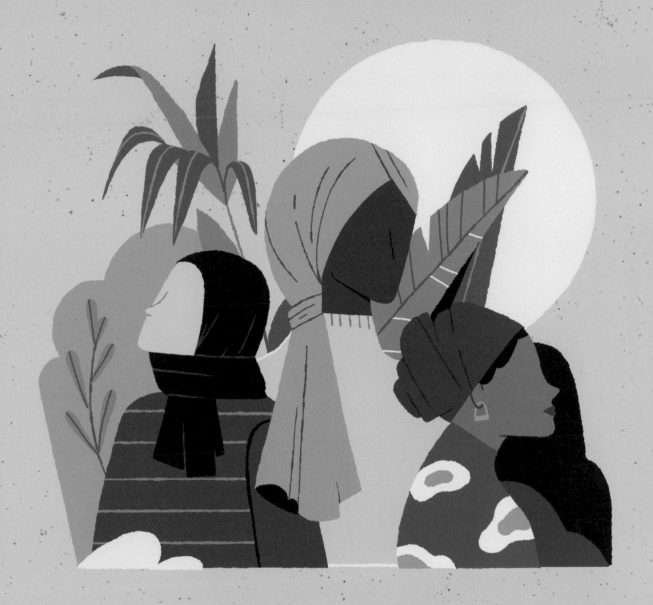

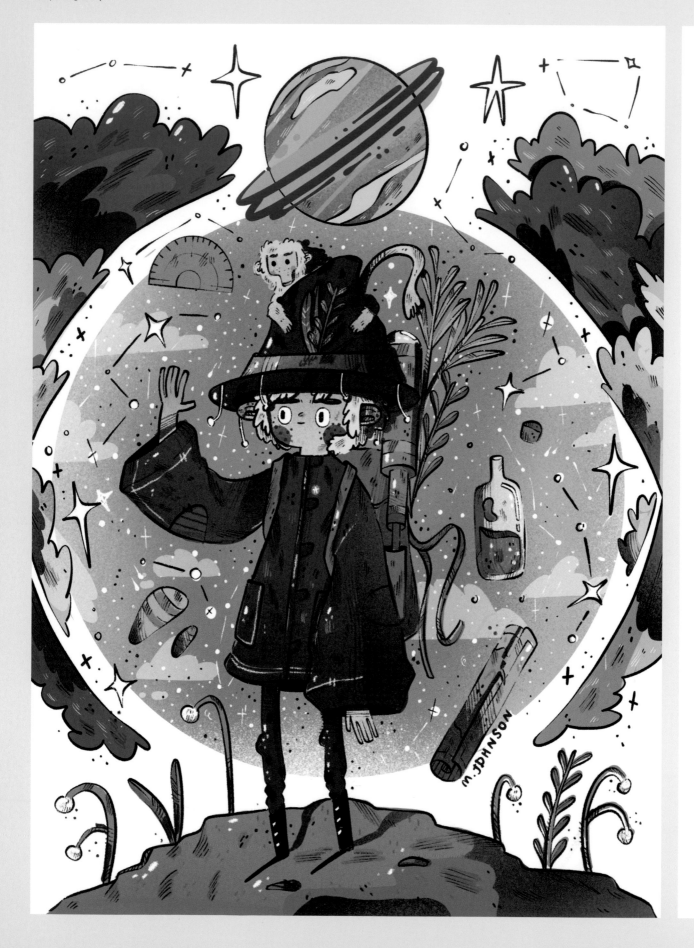

Meggie Johnson | meggiejohnson.com | All images © Meggie Johnson

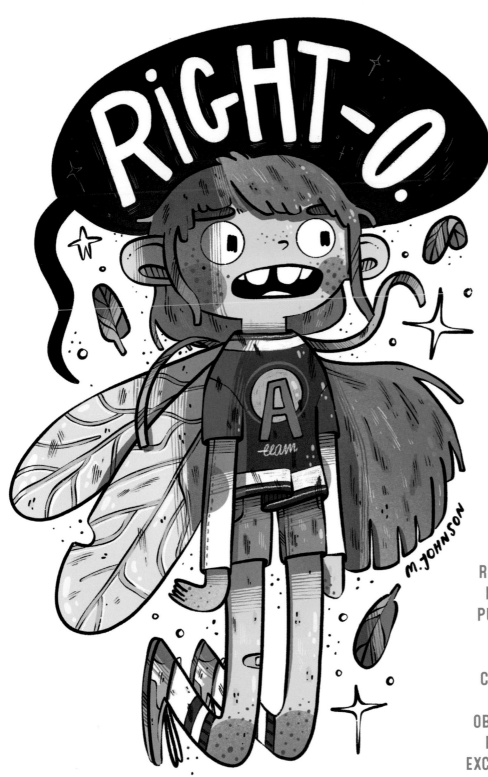

MEGGIE IS A DIGITAL
ILLUSTRATOR BASED
IN LONDON, WHO
RECENTLY RECEIVED AN
MA IN INTERNATIONAL
PUBLISHING. SHE LOVES
WORKING WITH BOLD,
BRIGHT COLORS, AND
CREATING CHARACTERS
OUT OF INANIMATE
OBJECTS. HER AIM IS TO
BUILD WORLDS FULL OF
EXCITEMENT, ADVENTURE,
AND CHILDLIKE WONDER.

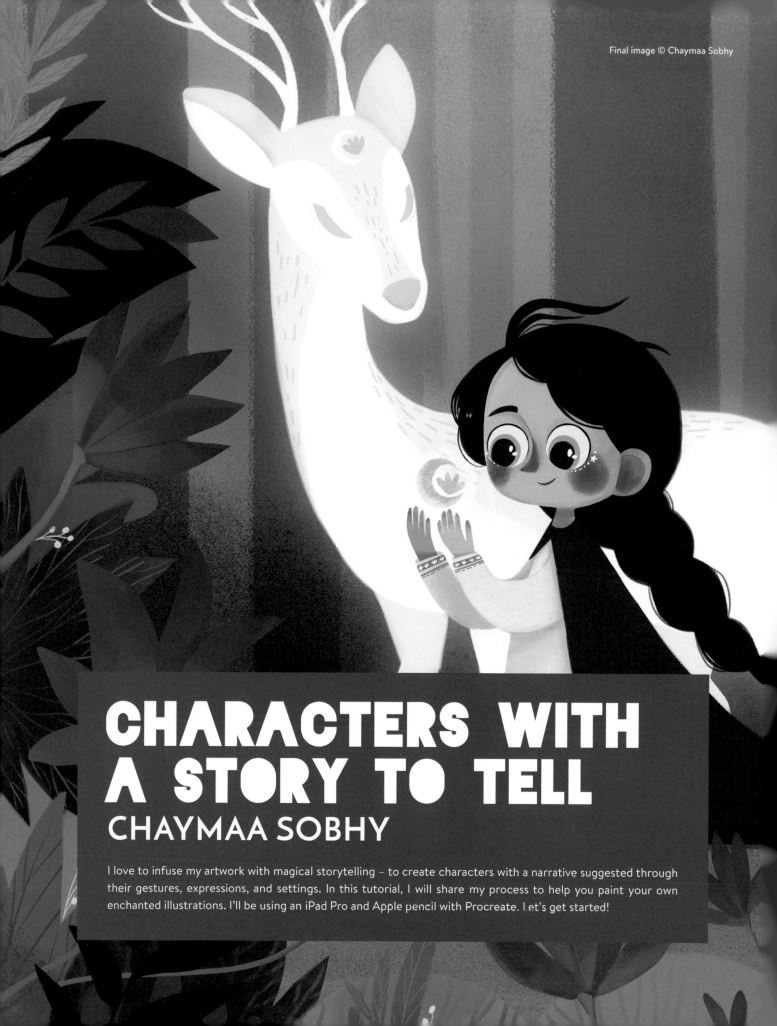

CHARACTERS WITH A STORY TO TELL

CHAYMAA SOBHY

I love to infuse my artwork with magical storytelling – to create characters with a narrative suggested through their gestures, expressions, and settings. In this tutorial, I will share my process to help you paint your own enchanted illustrations. I'll be using an iPad Pro and Apple pencil with Procreate. Let's get started!

START WITH SKETCHING

To begin, consider the narrative you want to portray in the final illustration, and quickly sketch some ideas. I love illustrating characters that interact with magical elements, so this becomes a base from which to build this design. I play around with the idea of a little girl with a magical deer, starting with loose sketches to get a feeling for the story and how the characters will interact. Keep making these little sketches until a vision for the final illustration has developed, before moving on to thumbnails.

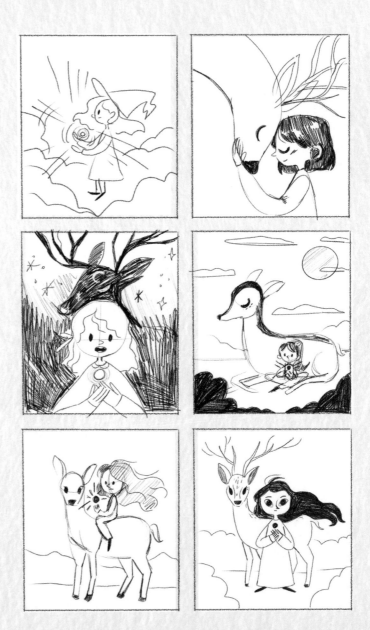

This page: Sketches of initial ideas, experimenting with the narrative for the illustration

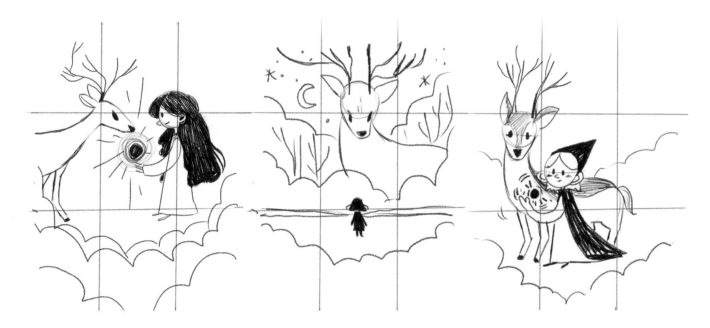

SETTING THE SCENE

Now it's time to create some thumbnail sketches. I tend to draw three to six, and although they are smaller than the final image, I keep the final dimensions in mind while I'm working. It helps to add a compositional grid over the sketches – this allows you to try different compositions until you find the one that works best. At this stage, experiment with various sizes for the characters, making them larger and smaller. For this particular piece, I end up with a centered composition – this will allow me to add plenty of depth in the foreground and details in the background.

INTRODUCING THE PROTAGONIST

Creating a unique character can be a challenge, but the process can be made easier by beginning with simplified shapes. Once you've created the main shape, you can start to add details such as hairstyles and outfits. References are especially important for this step. If you have trouble drawing hairstyles, researching and simplifying the styles down to shapes and outlines will also help – details can be added later. In this case, I want to include some magical details, so I add a cape. Little details like this can bring your character to life and help it pop from the page. I also decide to add flower details to her dress, which will be repeated throughout the illustration.

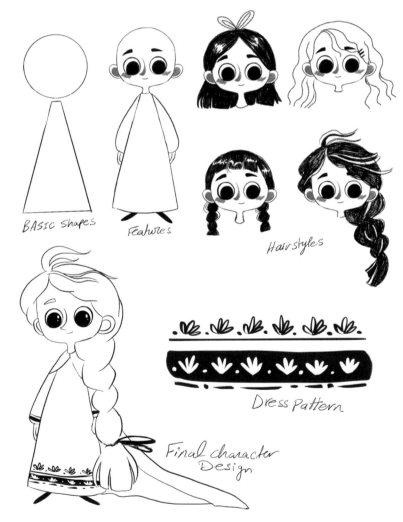

BASIC shapes

Features

Hairstyles

Dress Pattern

Final character Design

RULE OF THIRDS

The rule of thirds refers to a simple composition technique in visual arts. When you open your canvas, make a grid by adding two equally spaced vertical and horizontal lines that divide your image into thirds in each direction. The points that intersect are called "points of interest" and placing key elements here will help to balance an illustration.

ANIMAL MAGIC

When designing an animal, it's essential to use real-life photographic reference of that animal, or similar animals, from multiple angles. Take a step back from the illustration and make some study sketches to figure out how the anatomy works, and how to translate it into simplified shapes for your design. Once you're comfortable with this, you can start drawing it into the final sketch.

Opposite page (top): Thumbnails to achieve a clearer idea of the final illustration and try different compositions

Opposite page (bottom): Small, considered details help make a character original

This page: Creating the secondary character for this illustration – a magical deer

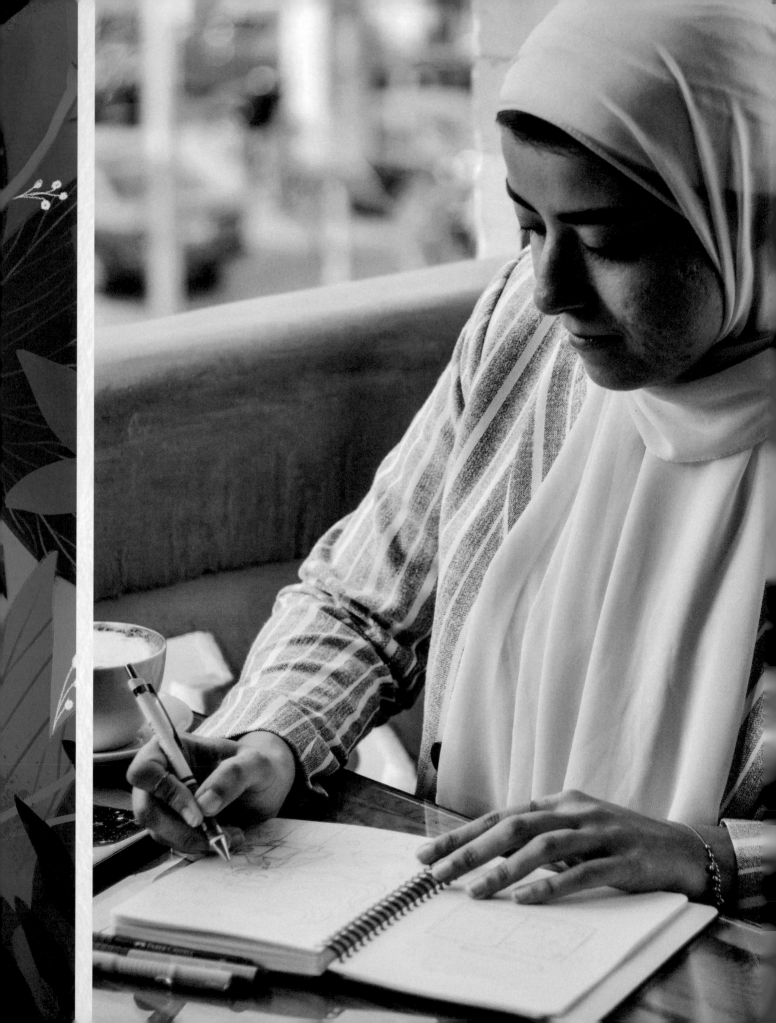

BUILDING A WORLD

As you might have noticed, I love planning out everything for the illustration individually and, once I'm feeling confident with it, combining everything into the final sketch. Therefore, at this stage, I sketch ideas for an environment for the characters to exist in. It's a good idea to play around with different shapes and sizes in your background scene to create interest. In the end, I opt for a simpler background to help keep the focus on the characters.

Opposite page: Me at work

Below: Various sketches showing environment ideas for the scene

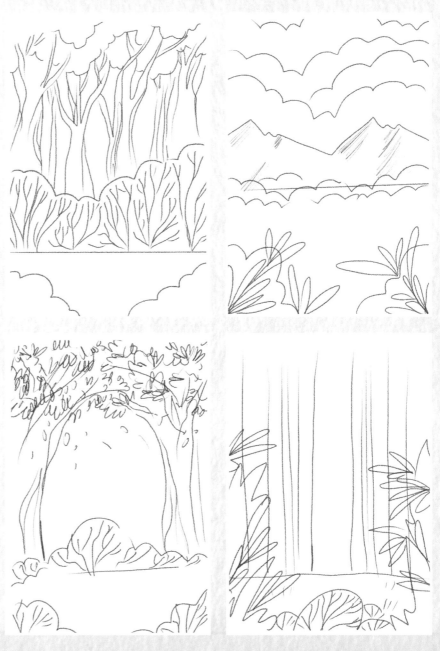

BRINGING THE DETAILS TO LIFE

We are almost finished with the painting! But before the story is complete, we need to add some more interest and life to the foreground flowers and leaves. To do this, I add some mixed colors from the palette, and give them a gradient effect using a textured or soft-edged brush. At this stage, I'm always pleased I drew details like these on different layers initially, as it means I can mix the colors and add the finer details now, without interfering with the other layers.

THE FINAL SCENE

One final touch I like to add to my paintings is a wash of watercolor – I use color-washed paper that I have already scanned into my computer. I add one of these on a new layer and reduce the saturation to minus-100% then I change the layer mode to Soft Light and reduce the opacity to 50%. For this particular illustration, however, I notice the texture is a little distracting – especially as I used a lot of textured brushes – so I reduced the opacity further to 5%.

Finally, I want to add a magical glow around the deer. To do this, I duplicate the layer that the deer is on and adjust the original layer – I use a blur (such as Gaussian) and reduce the opacity to 50%. When the blurred layer sits underneath the "normal" deer layer, it gives the deer a bright, glowing effect. These little adjustments add a touch of magic and help the characters tell their story in the final illustration.

This page (top): Adding the final details to the foreground elements

This page (bottom): My studio

Opposite page: The final image

Final image © Chaymaa Sobhy

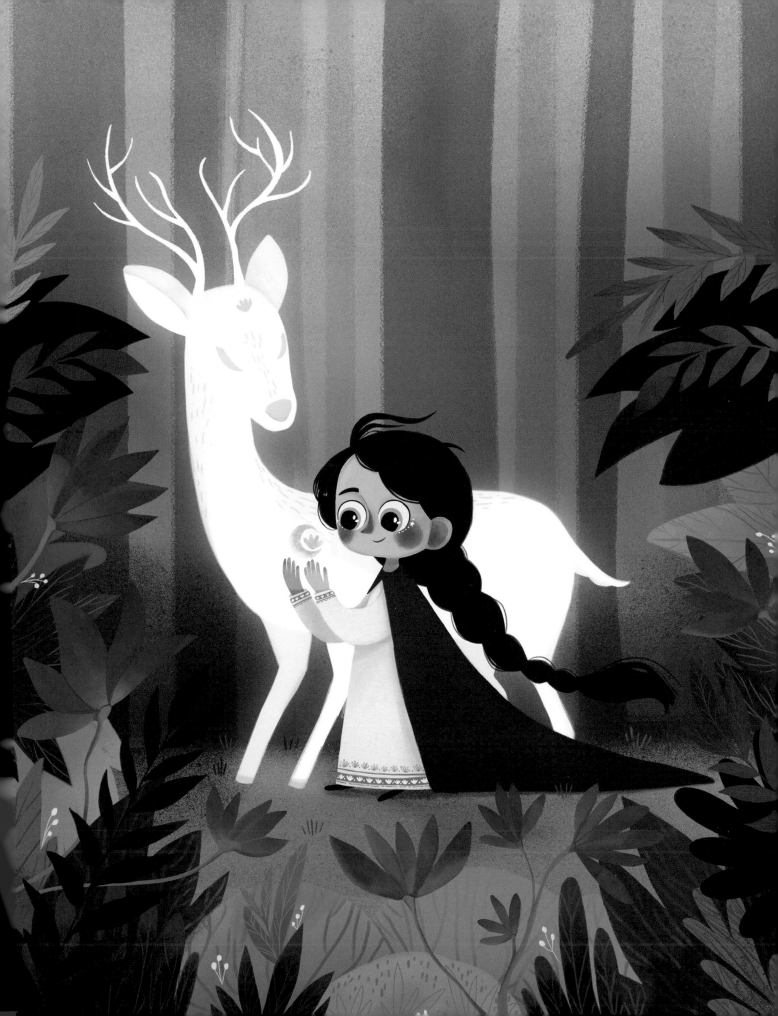

CONTRIBUTORS

KEI ACEDERA

Creator and co-founder of Imaginism Studios & Schoolism
imaginismstudios.com

An Emmy Award-winning artist working in the movie industry. She has designed for projects such as Tim Burton's *Alice in Wonderland*.

RAYNER ALENCAR

Production designer at Miralumo
artstation.com/rayneralencar

A Brazilian artist who lives, breathes, and eats animation. His previous clients include Passion Pictures, WarnerBros, and Nickelodeon.

BOBBY CHIU

Creator and co-founder of Imaginism Studios & Schoolism
imaginismstudios.com

Bobby has won many awards for his work, including an Emmy. He teaches online, runs LightBox Expo, and works as a character designer.

EMMA CORMARIE

Currently studying for a Visual Development MA in San Francisco
emmacormarie.com

A French American student and visual development artist. She has so far worked for Dreamworks TV, Golden Wolf, and more.

OONA HOLTANE

Character designer at Netflix Animation Studios
oonaholtane.com

A character designer and illustrator working in animation. Her passion is telling colorful stories, using worlds and characters to spread positivity.

DIANA MÁRMOL

Freelance character designer and illustrator
instagram.com/dianammarmol

A Spanish artist obsessed with efficiency and quality in design, plus beautiful shapes, carefully selected color palettes, and simplification.

KATE PELLERIN

Freelance children's book illustrator
poopikat.com

Kate, aka Poopikat, is a Canadian artist based in Toronto. Her current specialty is children's book illustration and character design.

RACHELLE JOY SLINGERLAND

Concept artist and freelance illustrator
instagram.com/rachellejoys

Currently working in Rotterdam, Germany, as a concept artist in advertising and animation, and as a freelance artist, too.

CHAYMAA SOBHY

Children's book illustrator and freelance artist
instagram.com/chaymaadraws

Based in Cairo, Egypt, Chaymaa has a love for warm colors and whimsical illustrations. She is a self-proclaimed bookworm and coffee-lover.

NOOR SOFI

Visual development artist at Taiko Animation Studios
noorsofi.com

Noor loves coming up with stories and wandering around art galleries. Her other hobbies include reading and eating sweets.

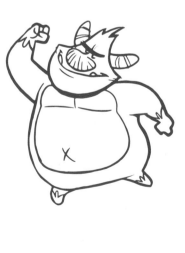

HAIR IN MOTION

BY LORENZO ETHERINGTON

ON THE PREVIOUS EXAMPLE WE WERE STARTING TO MOVE THE HAIR AS A **SINGLE FORM**, BUT TO ACHIEVE MORE REALISM AND NUANCE, IT'S HELPFUL TO VISUALISE THE **SEPARATE MOVEMENTS** OF **DIFFERENT AREAS**.

- WEIGHT OF HAIR KEEPS THIS AREA DOWN
- FLATTENS TO SHAPE OF SKULL
- REAR HAIR FLARES OUT
- MAIN BODY OF HAIR LIFTS IN A WAVE
- INTERIOR ENDS SEPARATE AND BLOW UP
- FRONT ENDS CATCH THE WIND AND LIFT

WIND/MOVEMENT

THESE **DIFFERENT AREAS** HELP YOU CAPTURE MORE **COMPLEX MOTION**.

LONGER HAIR = MORE SEPARATION

WITH HAIR PULLED BEHIND

FAN OUT BENEATH

FROM **BEHIND**, WE SEE THE DIRECTION THE HAIR TAKES FROM **THE PARTING** MORE CLEARLY.

TEAR-DROP

FINER HAIR

YOU CAN EXAGGERATE FURTHER

FIND THE CENTRAL LINE FIRST

THICKER, TANGLED GROUPS - MORE LIKE DREADLOCKS

SOME **MORE NOTES** ON **OTHER KINDS OF MOVEMENT:**

1 TWISTING HEAD

2 LONGER HAIR TWIST

3 BLOWN UP

PARTLY COVERS FACE

BILLOWS UP LIKE A JELLYFISH!

4 MID-JUMP

5 EXPERIMENT! INVENT!